MILLENNIALS OF NEW YORK

Alec MacDonald

AND

Connor Toole

G

GALLERY BOOKS

New York London Toronto Sydney New Delhi

G

Gallery Books
An Imprint of Simon & Schuster, Inc.
1230 Avenue of the Americas
New York, NY 10020

First Gallery Books trade paperback edition October 2016

GALLERY BOOKS and colophon are registered trademarks of Simon & Schuster, Inc.

For information about special discounts for bulk purchases,
please contact Simon & Schuster Special Sales at 1-866-506-1949
or business@simonandschuster.com.

The Simon & Schuster Speakers Bureau can bring authors to your live event.
For more information or to book an event, contact the Simon & Schuster Speakers Bureau
at 1-866-248-3049 or visit our website at www.simonspeakers.com.

Interior design by Akasha Archer
Ghost emoji created by WARPAINT Media Inc. from Noun Project
Music emoji created by vre baz from Noun Project
Heart emoji created by Prasad from Noun Project

Manufactured in the United States of America

1 3 5 7 9 10 8 6 4 2

Library of Congress Cataloging-in-Publication Data
Names: Toole, Connor, compiler. | MacDonald, Alec, 1988- compiler.
Title: Millennials of New York / [compiled by] Connor Toole and Alec MacDonald.
Description: First Gallery Books trade paperback edition. | New York :
Gallery Books, 2016. | Collection of quotes by Generation Y (Millennials) interviewed in New York City.
Identifiers: LCCN 2016018506| ISBN 9781501143083 (pbk.) | ISBN 9781501143090 (ebook)
Subjects: LCSH: Generation Y—New York (State)—New York—Humor. | Generation Y—New York (State)—
New York—Quotations, maxims, etc. | Conduct of life—Humor.
Classification: LCC PN6231.G385 T66 2016 |
DDC 818/.602—dc23 LC record available at https://lccn.loc.gov/2016018506

ISBN 978-1-5011-4308-3
ISBN 978-1-5011-4309-0 (ebook)

MILLENNIALS OF NEW YORK

Dedicated to Mark Ruffalo

People care what I think.
I have a prestigious blog, sir.

—*Party Down*

INTRODUCTION

Alec MacDonald and Connor Toole are journalists by profession, but first and foremost, they are proud Millennials.

For the layman, the Pew Research Center defines this to be anyone born between 1981 and 1997. Now, there is some dispute here—as many believe that generations are becoming more and more fluid—but these are the parameters that MacDonald and Toole agreed to work within for the purposes of this book.

Over the last few years, the two journalists came to feel that their generational peers had been tragically misrepresented by the media as shallow, apathetic, and self-obsessed. So a little over a year ago, they decided to do something proactive to change this perception.

The two journalists pooled what money they had left over from their last job—a thrilling exposé on the frequency of sexual assaults among house cats that was brushed under the rug by PETA—and purchased a camera on Craigslist. Then they hit the streets of NYC and began reporting.

Their primary goal was simple: to photograph and interview each Millennial they encountered in their natural habitat. Their secondary goal was to circulate extensive surveys among the native Millennial population so that they could back up their anecdotal findings with hard data.

MacDonald and Toole—unconcerned with monetizing their endeavor—promptly set up a Facebook page to disseminate their findings en masse. And they were happy to see their

page grow swiftly in popularity. Millennials, it became expressly clear, had been starved of accurate representations of themselves.

It was because of the popularity and cultural impact of their social media pages that they were approached by prestigious publishing companies. They settled on Simon & Schuster, who have published the works of Ernest Hemingway, F. Scott Fitzgerald, Gillian Anderson, and other luminaries.

This book is a compilation of their most telling and representative encounters with the people of their generation. The intelligence and authenticity displayed by the subjects photographed here may shock older readers, but fellow Millennials will finally see themselves reflected as they truly are: compassionate, wise, kind, politically active, racist, highly intelligent, and, above all, down to earth.

MacDonald and Toole welcome readers of all ages—they just ask their older readers to keep an open mind.

"This is my favorite shirt. I love Buddhism."

Indigo, Apple Genius

"Buying organic and local is just a way of life for me now. It's just so important to me that I know where the stuff I buy is being farmed and who is doing the work. That's why I'm proud to say my weed guy lives in my building and the weed I smoke is sourced from a secret roof garden in Queens, as it should be."

Jess, yoga instructor

"My ex-boyfriend was a huge hipster. I loved him so much. But he was so retro that when he got the flu he just died."

Hannah, wine critic

"My girlfriend and I have been together for three years, and we couldn't have done it without Netflix. A decade ago we would've definitely broken up by now, but with Netflix streaming, it's amazing, we barely even have to think about how much we hate each other. She can say things like 'If you take a bite of my sandwich I'm going to set your fucking cat on fire,' and I can throw that sandwich out the window and punch another hole in the wall. Then, all we'll have to do is switch on *Pretty Little Liars* for six hours to slowly bury all that misery back down inside our cold, loveless hearts, where it belongs. We can't thank you enough, Netflix. We're getting married in the fall."

Joe, engaged

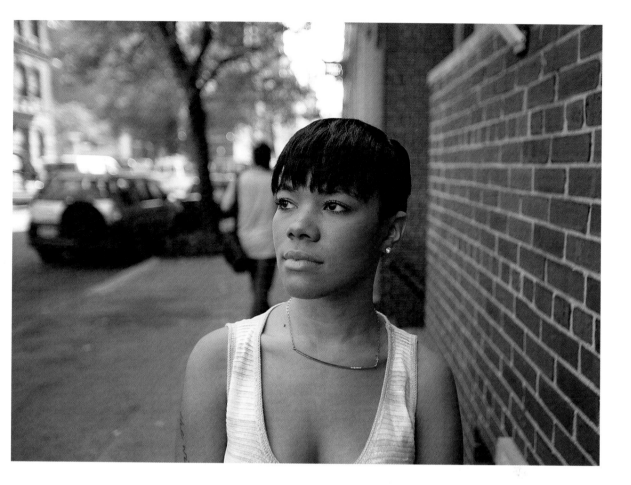

"If I had a reality TV show about my life, it would probably be called *Keeping Up with the Accomplishments of People I Know on Facebook*."

Kayla, on a journey of self-discovery

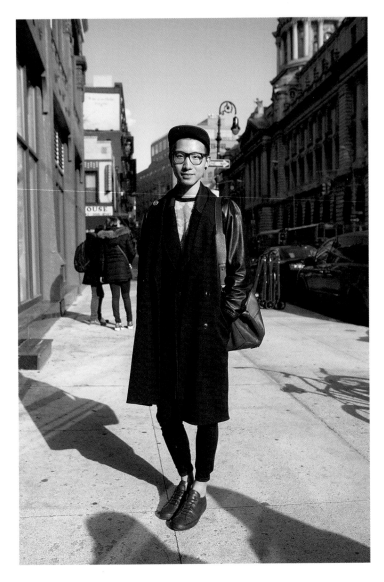

So what kind of artist are you?

"Well, right now I'm working on this performance piece about capitalism where I collect old receipts and add up all the prices."

So you're an accountant?

"Yes."

Henry, artist

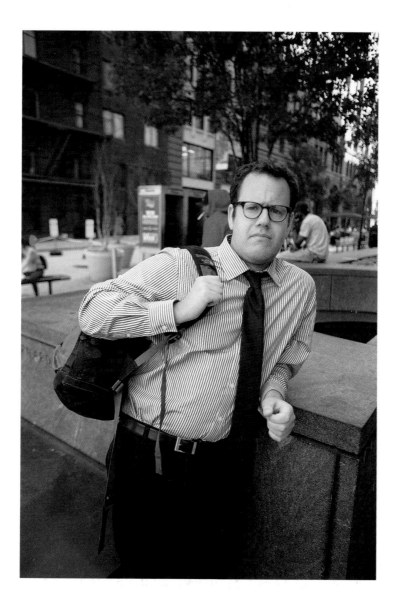

"There is no such thing as white privilege. Look, I've had more than a few run-ins with the police, and they're not very nice to me either. I mean, just last weekend I drunkenly grabbed a cop's gun, and even though I was obviously joking, he called me 'incredibly irresponsible,' and was, like, super stern and passive-aggressive the entire time he was giving me a ride home."

Zach, Caucasian

"I'm a journalist."

Peter, phone owner

"If I could live in any decade, it would definitely be the '60s. It was just such an amazing time to be alive. Who's the most popular band in the world right now? One Direction? I'd rather grow up listening to visionaries like the Beatles instead of some crappy boy band from England with weird haircuts. Plus, think of all of the iconic stuff to come out of the era. There was Woodstock, flower power, the Rolling Stones, skinny ties, stylish secretaries, MLK, the assassination of MLK, the assassination of JFK, the assassination of RFK, the Vietnam War, the Kent State shootings, the Cuban Missile Crisis, rampant sexism, legalized racism, the constant threat of nuclear annihilation, and the Beach Boys! How can you forget the Beach Boys? I guess I was just born too late."

Taylor, old soul

"Hey, do you have a second to ignore me?"

Ralph, scum

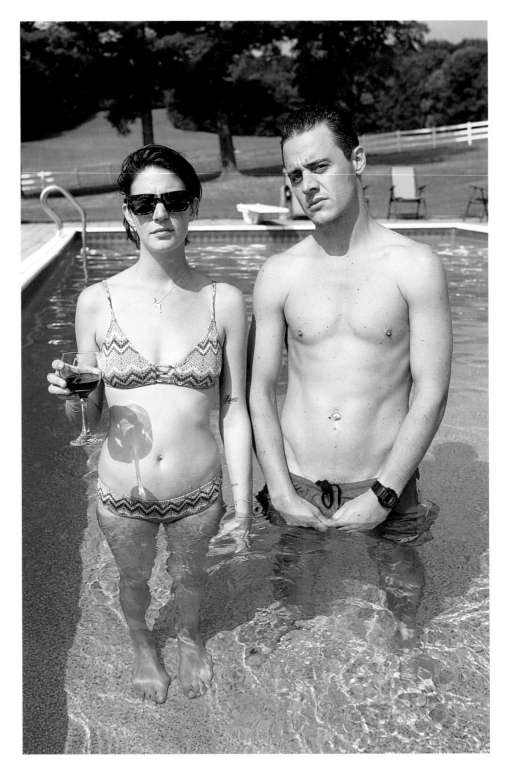

"We got married two weeks ago. It was an absolutely beautiful ceremony. I wouldn't have done anything differently. Some people said it was tacky to make the priest hold the selfie stick when we kissed, but they can tell that to the 271 likes the picture got on Facebook. Now we're on our honeymoon. It's so beautiful. I've been spending most of my time staring longingly at our Instagram notifications while holding his hand and thinking about how many likes we'll get for making a baby."

Lizzie and Mike, married

"873."

Lizzie, mother

"It's literally impossible to take advantage of the city when everything is as expensive as it is. Isn't the mayor supposed to be doing something about these ridiculous rent prices? It feels like by the time I'm done paying for other basic necessities—groceries, electric, internet, MetroCard, Sunday brunches, margarita-machine maintenance, feather-headdress-making lessons, Saturday brunches, an officially licensed SoulCycle machine for my apartment so I don't have to worry about classes filling up—there's really nothing left for me to have any fun with. I don't want to ask my parents to up my allowance, but I don't know if I have a choice anymore."

Diane, social media consultant

"We live in such a politically contentious and difficult time, but so few people my age are actually willing to do anything about it. People need to WAKE up and smell the ESPRESSO. That's why I always share political articles on Facebook whenever I see them. In fact, I share so many that I don't have time to actually read any of them—that's how hard I'm working to make this world a better place. But some people I know hardly share political articles at all. It's like they don't even care about the pending avocado shortage, or whatever is happening in Africa. I'm doing my part, but honestly, I can only share so much."

Britney, progressive

"The Rock and I are both 'men' in the same way that the Declaration of Independence and a Blockbuster rental receipt for *40 Days and 40 Nights* are both just old pieces of paper."

Norman, Apple Watch repairman

"The best thing about graduating college is that amazing feeling of *independence* you get when your mom finally knows she should knock before bringing your laundry into your room."

Austin, commutes from New Jersey

"I decided to work in finance because ever since I was a little kid, I've wanted to be really vague whenever someone asks me what I do."

Evan, finance

"While I was a student at NYU, I was more pretentious than James Franco wearing a beret while reading a French newspaper and discussing the merits of acupuncture. But after a lot of soul-searching and some really humbling postcollegiate life experiences, now I'm only as pretentious as Shia LaBeouf explaining tae kwon do."

Joaquin, part-time playwright, full-time babysitter

"I have a lot of white friends. I like them, but they're obsessed with trying to convince me that they aren't racist. Last week one of them told me he couldn't possibly be prejudiced because, as he put it, 'I always tip deliverymen and cabdrivers.' Another one is constantly bringing up the time she hooked up with two Indian guys in the same night. According to someone else who was there, it was actually the same guy, just an hour apart. Apparently he wasn't wearing a hat the second time. I need different friends."

Timothy, systems architect

"You can't move to New York City unless you're not afraid to fail. I think that's why I've been so successful—I'm not afraid of having to ask my parents for money when I start running out. It's really changed my whole outlook on life."

Brooke, hand model

"I went into a hairspray-induced coma on December 30, 1989, and woke up two weeks after the start of the new millennium. Meaning, I literally don't remember the '90s. For years, I was terrified that there would be no way for me to make up for lost time, but then someone told me about BuzzFeed. 'It's this website that just posts lists of things that happened in the '90s.' I couldn't believe it. If it wasn't for all these people exploiting nostalgia for page views, I would have assumed 'Squirtle' was just the name of a Japanese sex toy everyone loved as a kid."

Maya, urban gardener

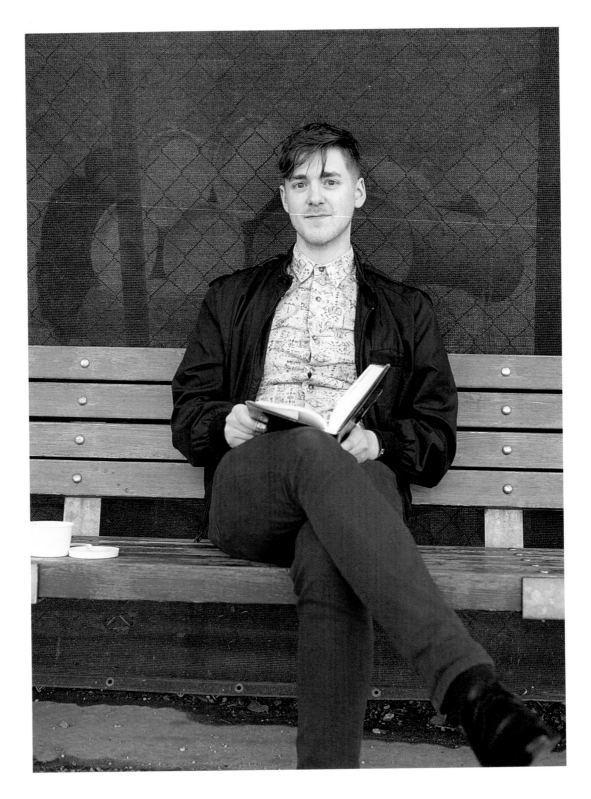

"My dream job is to be multiracial."

Pierre, college student

CULTURE AND THE ARTS

REASONS MILLENNIALS GO TO ART MUSEUMS

INSTAGRAM OPPORTUNITIES

INTERNET IS OUT AND I CAN'T GET PORN ANY OTHER WAY

MUSIC APPRECIATION GRAPH

HOW MUCH YOU ENJOY BILLY JOEL

"CHILL OUT, CHILL OUT, YOU'RE EMBARRASSING YOURSELF."

1 2 3 4 5 6 7

NUMBER OF DRINKS YOU'VE HAD

STATS

The Books Most Prominently Displayed in Millennial Apartments, and the Average Percentage of Said Books That They Have Read
1. *On the Road*, Jack Kerouac (77%)
2. The Harry Potter series, books 1–7, J. K. Rowling (47,578%)
3. *Bossypants*, Tina Fey (91%)
4. *Freedom*, Jonathan Franzen (100%)
5. *Infinite Jest*, David Foster Wallace (0%)

Authors Most Discussed Past Midnight
1. Hunter S. Thompson
2. Charles Bukowski
3. Ernest Hemingway
4. Adolf Hitler
5. Joan Didion

Posters Most Commonly Found Tacked to Millennials' Walls
1. Warhol's *Campbell's Soup Cans* (1962)
2. Van Gogh's *Starry Night* (1889)
3. Bud Fraker's Audrey Hepburn with cigarette holder (1961)
4. Monet's *Water-Lily Pond* (1899)
5. Lance Serpico's *Two Hot Lesbians with Headphones Making Out* (1997)

Average Weight of Fecal Matter Between Pages of the Bathroom Copy of the *New Yorker*
.057 G

Total Amount Spent Annually by Millennials to See Their Friends' Bands
$6.1 million

Net Worth of Mark McGrath
$6.1 million

Number of Millennials Who Think That "Tom Waits" Is the Name of a Duplass Brothers Comedy
1 in 10

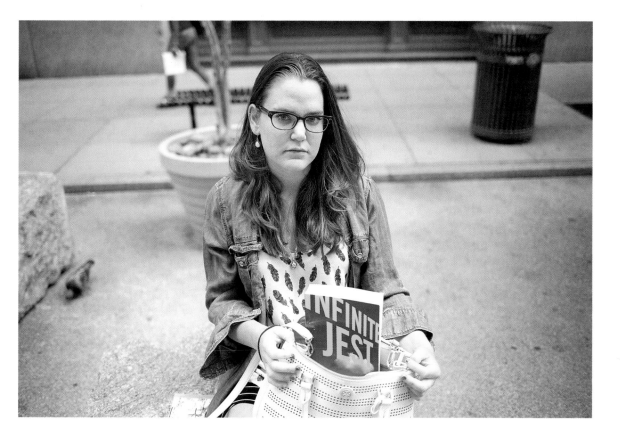

"All of my friends have started reading books on their iPads and Kindles, and to tell you the truth, I'm disgusted. Call me a Luddite, but I just don't think you can truly appreciate a novel without having a physical copy. After all, it's so much harder to convince potential sexual partners that you're an intellectual when all of your books are on the cloud instead of a strategically placed bookshelf from IKEA. Plus, what's the point of reading *Ulysses* on the subway if nobody knows you're reading Joyce? I mean, that book makes literally no sense—I just stare at words and turn the page every few minutes. I guess you can do that with an ebook, but it really isn't the same."

Alice, graduate assistant

ALEC MacDONALD AND CONNOR TOOLE

"I'm a professional talent scout. I spend my days walking around the city looking for a subject that I can turn into the next big meme. My primary focus used to be cute, exotic animals—your slow lorises, your three-toed sloths—but just being adorable doesn't cut it anymore. Right now, disabilities are IN. Whether it's Grumpy Cat's malformed jawbones or Lil Bub's total lack of teeth, people just can't get enough of broken animals! This little guy has diabetes. Type 2. He's gonna be huge."

Anastasia, meme scout

"I legally changed my name to ."

, *SAT tutor*

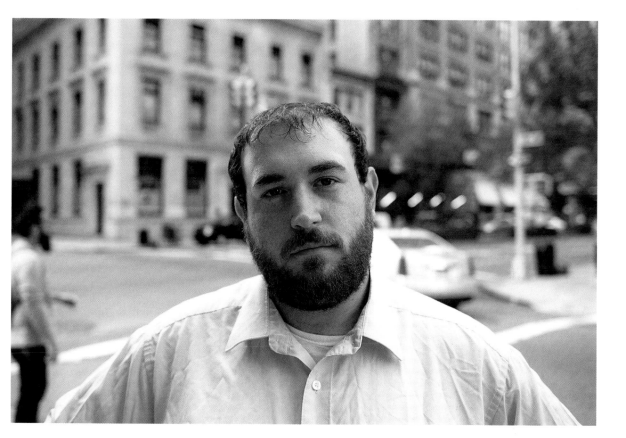

"There aren't many things I'm concerned about more than my right to privacy. Thanks to American heroes like Edward Snowden, I'm extremely conscious about other people digging into my personal life. This country used to respect a man's privacy. My grandfather never had to look at porn in an incognito window. If he wanted to be incognito, he just took his photograph of Amelia Earhart to the attic."

Logan, feeds squirrels

"For a while, I wanted to be a novelist—I even received an MFA in fiction writing from a prestigious graduate school. Now, I'm proud to say I work in an office doing 'Business Stuff' like my dad. The people here pay me according to how long I can handle being bored without losing concentration. Or peeing. Also, I get to wear a tie. It's just like *Mad Men*. So, yes, I am very happy."

Alec, Razor scooter owner

"For months I was utterly miserable. I was going to therapy three times a week and actually listed 'crying' as one of my hobbies on Tinder. After realizing nobody was going to solve my problems for me, I went to the zoo and paid $80 to have my picture taken with a penguin wearing a tiny sweater. I posted it on Instagram and it got 123 likes! 123!! I suddenly felt like my life had been filled with a purifying, healing light. I was able to completely stop going to therapy, and last weekend my ex even texted me 'Mouth?' at 3 a.m. I think things are finally starting to turn around. Thank you so much, Instagram."

Aly, Tinder coach

"I work at a news agency. It's my job to come up with the nicknames we give every celebrity couple. You know 'Kimye'? That paid for every single one of my hot yoga classes last year. The only catch is we have to have them prepared before people start dating, which means we have to take every possible relationship into account. One time, I had to figure out what we'd do if Phyllis Diller started dating the guy who did 'Gangnam Style.' It took me a while, but I finally came up with the perfect one: 'Psyphyllis.' I was crushed when I heard she died before they had a chance to fall in love."

Gretchen, celebrity relationship expert

"Mouth?"

Caleb, vegan butcher

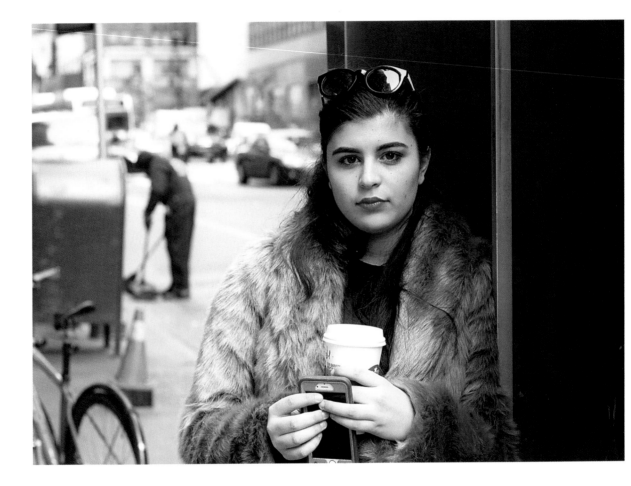

"I don't do drugs. I don't need to. Why risk getting addicted when life is full of so many simple pleasures—a freshly baked baguette, a decadent dessert, a warm cup of coffee. God, I love coffee. I've been drinking it every day for over a decade now. I used to be able to get by on a small cup from Starbucks, but as I've started to drink more, now I need the strongest brew that I can get my hands on. I've learned that if you want the highest quality stuff you've got to source your beans directly from South American countries like Colombia, Bolivia, and Peru. Sure, there are some months I spend so much money on coffee that I can barely afford lunch. And yeah, sometimes when I don't have my coffee, I can get a little irritable and, you know, I occasionally lash out at my loved ones. They keep telling me I should try to cut back, but I can't handle the splitting headaches I get whenever my buzz wears off. Maybe they just need to learn to mind their fucking business."

Marissa, interior designer

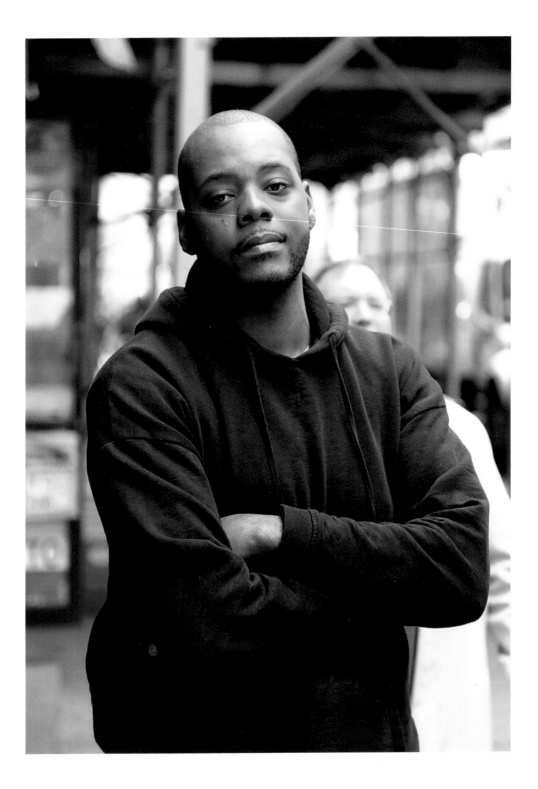

"I'm training for the marathon. It's a lot tougher than I thought it would be when I first started out. It's really hard to build up your endurance when you get stopped by the NYPD every fifteen minutes because they think you just robbed a sporting goods store."

Sean, creative director

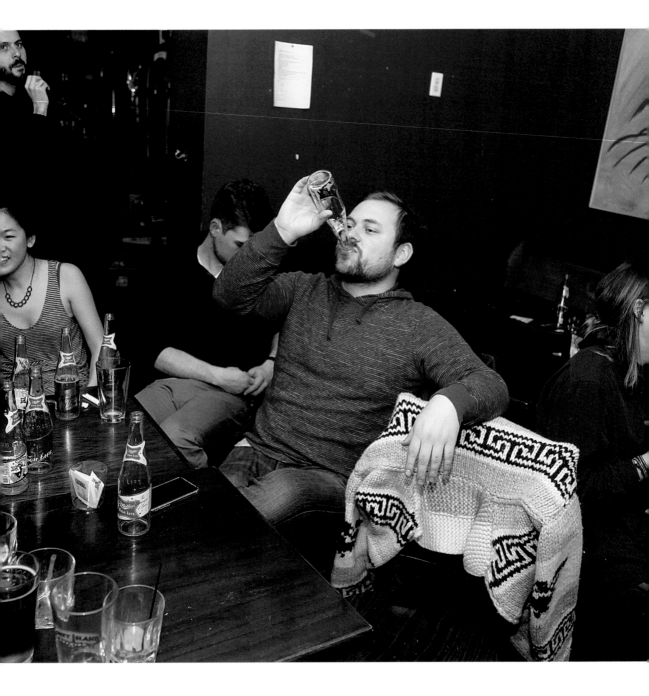

"To be honest, dude, the only things I learned how to do in college were BANG chicks, completely DOMINATE at pong, CRUSH beers, and ALWAYS REMEMBER that although the Soviet experiment was ultimately a failure, that failure cannot and should not be attributed to any fundamental flaw in Marxist philosophy but rather to humanity's primal tendency to abandon ideology in favor of power and influence."

Robbie, soup kitchen volunteer

"Honestly, it's pretty hard being a female comic, but luckily I have some really helpful male stand-up peers to motivate me. When I was first starting out I had a lot of terrible sets, and the guys told me encouraging stuff like 'Don't worry, Becky! You'll get them next time!' And then, when I started to do a little better and wasn't bombing all the time, they told nice me stuff like 'You were definitely the funniest girl tonight.' And when I eventually started performing at bigger venues they told me flattering things like 'People must really like hearing girls tell jokes.' And when I started headlining shows they said encouraging stuff like 'So who'd you have to sleep with?' And when I started writing for television they gave super-honest feedback like 'bitch' and reassuring stuff like 'whore.' And then, when I sold a pilot to a major network, they asked if I needed any writers. Thanks so much, guys! I'll never forget everything you've done. Even if the rest of the world already has."

Betsy, stand-up comic

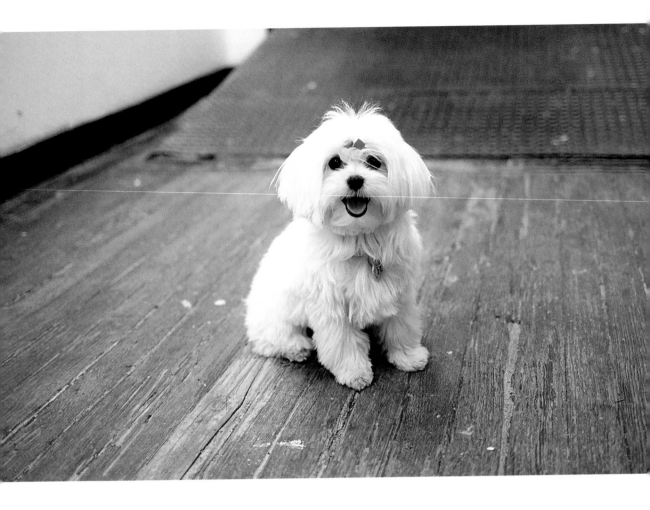

"I don't like to talk about it, because it's really such an unrealistic life goal to even think of having. But, okay, I'll tell you. My dream is that maybe, with enough hard work, dedication, and the loving support of my family and friends, I can one day be a meme."

Mitzy, dog

"I don't understand how people can eat at a corporate chain like Chipotle when there are so many more authentic options all around the city. Before I try out a new taco place, I ask for a glass of water. If it doesn't give me diarrhea, it's not authentic enough for me."

Raven, receptionist

"My current goal in life is to eventually make enough money to assume my maid is stealing from me."

Abigail, equestrian

"I honestly think society puts too much pressure on people to grow up before they're ready emotionally. I'm 29 years old—sorry if I don't want to put myself in a box for the rest of my life."

Carl, promoter

"My therapist told me it was important to start being nicer to myself. I realized she was right. Now I make sure to like all my Instagram posts the second they hit 10 likes."

Amanda, French Bulldog walker

"Lots of people say summer in the city is too hot, but I love it. In fact, I'm starting to feel really depressed that it's almost over. Pretty soon it'll be winter and my opportunities to be shirtless in public will shrink nearly to zero. I'll have to resort to spilling sauce on my shirt at dinner parties or, like, hoping I spot a kid drowning in the Hudson so I can tear off my shirt and dive in to help him. I just need to make sure people are around to watch. Otherwise, I'll have to wait until it gets more crowded, and by that time the kid might be dead and I'll need to wait for an entirely different kid to drown. It's like, if you have a hot body, but there's nobody around to see it, do you really have a hot body at all?"

Xavier, physical therapist

"I've never been to Times Square on New Year's Eve because I've never felt the need to experience what it would be like to be in the coldest and most tightly packed subway car in the world that takes six hours to go nowhere."

Travis, stylist

"I'm in branded advertising, but my real passion is history. I'm a huge history buff. I mean, did you know that in 1626 the native American Apparels sold Manhattan Storage to the Von Dutch for only $23? Isn't that so crazy?"

Julia, branded-content writer

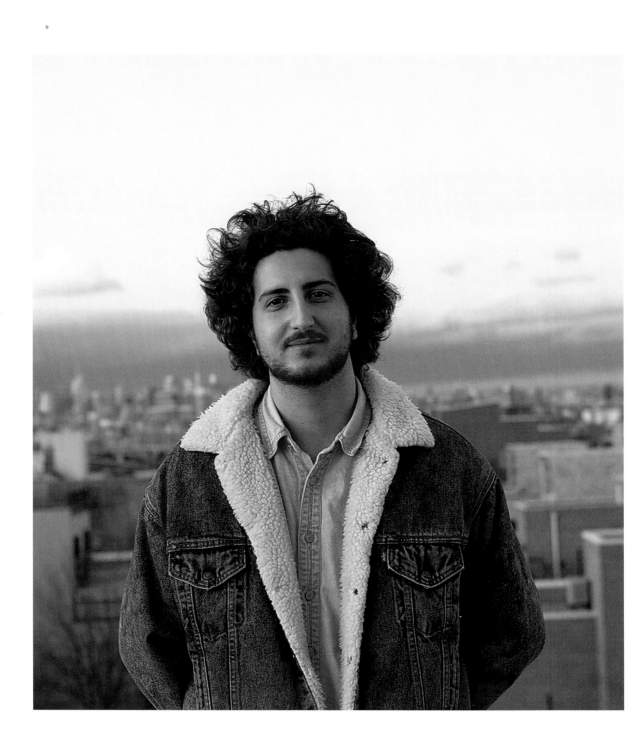

"I try to live each day like it is my last:
I say goodbye to people a lot, I'll have sex with anyone, and I'm constantly crying."

Daniel, meme sharer

"You see, the thing no one realizes about Christopher Hitchens is that he was basically like the intellectual Padawan of Gore Vidal. I mean, people just shit on him because of the one time that he said girls aren't as funny as men, but he was so much more *profound* than that, and I hate that that's all that anyone even talks about now with regard to him—this is literally the best popcorn I've ever had."

Dan, intellectual

"Um. I like your place. It's nice. Lots of books. I like that. I like girls who have books. You ever read any Christopher Hitchens? I can lend you a book of his, but you have to promise to give it back. Sorry. I've just been betrayed before."

Dan, intellectual

"I can sleep here, right? At my place I keep waking up with all these weird little bites."

Dan, intellectual

"What? I like sex."

Hannah, media strategist

"My doctor said I need to stop smoking if I want to lower my risk of cancer. I told him he might want to go back to med school. I'm a Sagittarius. Everyone knows we're not compatible."

Dakota, meteorologist

"This generation is so apathetic. People don't want to get out there and actually make a difference, so I've taken it upon myself to try and enact some real change. There's an epidemic out there and I can't believe I'm the only person who seems to care about one of the most pressing social issues of our time: people posting sexy selfies on social media with completely unrelated captions. If I see one more picture of a butt in the mirror of a cruise ship bathroom with the caption 'Love my family!!! #namaste' I'm going to set a national park on fire. Support the cause. Be on the right side of history."

Allie, activist

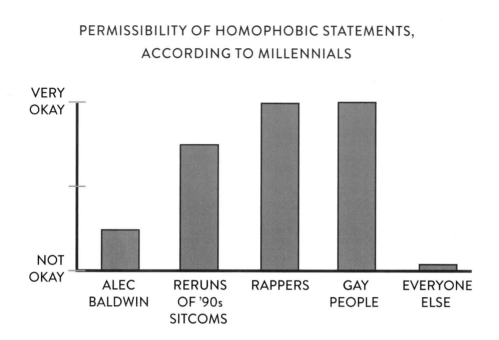

PERMISSIBILITY OF HOMOPHOBIC STATEMENTS, ACCORDING TO MILLENNIALS

VERY OKAY

NOT OKAY

ALEC BALDWIN · RERUNS OF '90s SITCOMS · RAPPERS · GAY PEOPLE · EVERYONE ELSE

STATS

Political Articles Read Before Being Shared
 1 in 6

Number of Times a Status Update Has Been Successful in Fundamentally Altering Someone's Core Political Philosophy
 1 (Mark Friedman, 29)

"Being stylish isn't easy. One month I spent so much on mustache wax and pomade that I could barely afford to buy ketamine. I decided to grow a beard, to save money, but by the time it was long enough to stick flowers in, that trend had already passed. Last year, I got the haircut that Brad Pitt had in that movie about war. But then all of a sudden every article on the internet was about how guys with man buns are the hottest people in the whole world, so I grew out my hair. Unfortunately, everyone forgot to mention that a man bun only makes you look hot if you already looked like Brad Pitt to begin with. I just look like an off-duty tap-dance instructor."

Brett, drug dealer

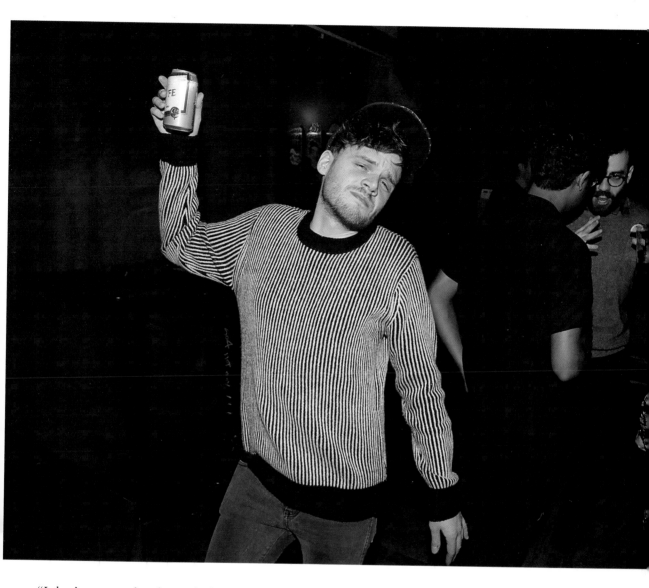

"I don't get people who can't dance. Dancing is easy. You just move your body around without humiliating yourself in front of all your peers or romantic prospects. You just do that."

Tristen, sushi chef at Trader Joe's

"It's crazy to think that one year ago I was just a naive girl from a small town who saved up enough money to hop on a Greyhound and move to the big city with nothing but the suitcase in her hand, the smile on her face, and the sparkle in her eye, who bought a ticket back home as soon as she stepped foot into a pile of human feces at the Port Authority bus terminal."

Grace, dreamer

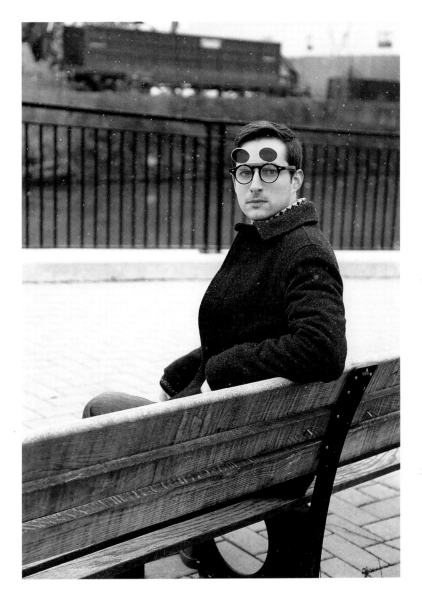

"A lot of people my age want to find a job that makes them financially independent and creatively fulfilled, or they want to find a romantic partner they think they might be able to share their lives with, or else they want to travel the world before they settle down."

And what do you want?

"I just want to know what 'algorithms' are."

Steve, copy editor

"I love coffee, but it's impossible to find a good cup in this city. Starbucks is the worst of all; how do they always manage to spell your name wrong? Plus how can you call yourself a coffee shop and not even offer latte art? Near my place there's a café with a barista named Lauren, and she always gets my name right because she's memorized it. Lauren draws the most amazing leaves in my foam every single morning—except Tuesdays, when she repairs vintage harps in her apartment. Would it really be so hard for Starbucks to hire more employees with tortoiseshell glasses, red hair as vibrant as their lipstick, and a stunning shoulder tattoo of Eleanor Roosevelt throwing a tomahawk? I just hate these big corporations."

Greg, socialist

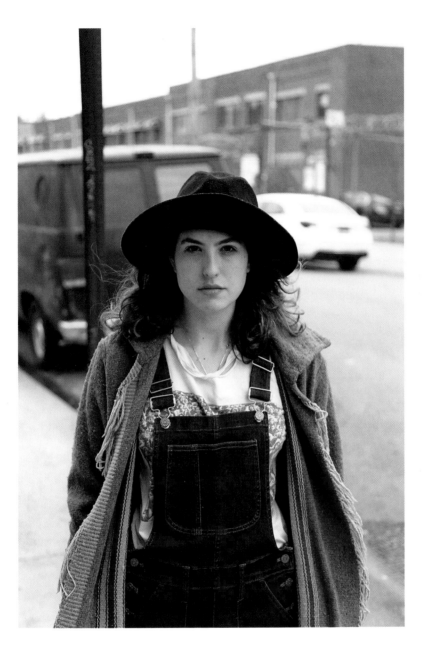

"I want to be the Lena Dunham of my generation."

Elizabeth, the same age as Lena Dunham

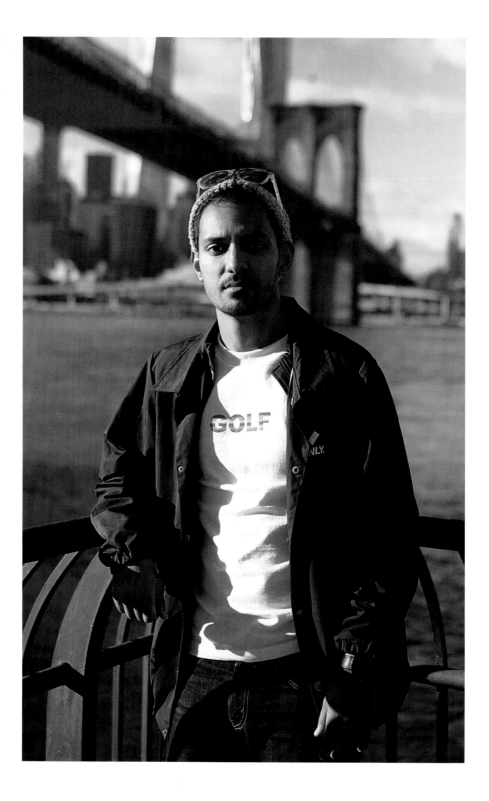

"Ambulances are like parents: Whenever you see them, they make you feel like what you're doing isn't very important."

Pete, mixologist

♫♪ *"SHE TAKE MY MONEY, WHEN I'M IN NEED*

YEAH SHE'S A TRIFLIN' FRIEND INDEED

OH, SHE'S A GOLD DIGGER WAY OVER TOWN

THAT DIGS ON ME

NOW I AIN'T SAYIN' SHE A GOLD DIGGER

BUT SHE AIN'T MESSIN' WITH NO BROKE NI . . .

. .

. .

. *um* .

. .

. .

. .

. .

. .

. *so, who's up next?*

. .

. .

. .

. *."* ♫♪

Laura, juice bar employee

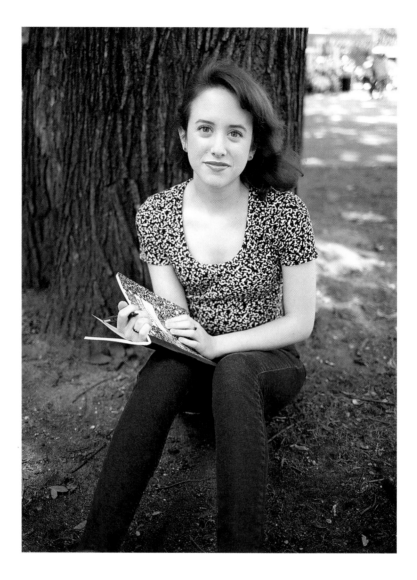

"It's really not easy balancing your love life, personal life, and professional life in this city. When I got too stressed in the past, I'd grab a drink with a friend or go to a park and throw coins at pigeons, but at some point all the regular things stopped working for me. Now the only way I can really relax is by watching TV shows about murder. After a long, stressful day, there's nothing I love more than popping open a can of rosé and trying to figure out who bludgeoned a prostitute to death with her own prosthetic leg."

Shannon, throws coins at pigeons

"I finally met this *amazing* girl. Seriously, she's absolutely incredible. She's tall, beautiful, spontaneous, gentle, lets me tell all the jokes, polite, silly, wise, lets me be the funny one, cool, stylish, understanding, leaves all the funny shit up to me, kind, sensual, and just so chill. Honestly, I think she's the one."

Lucas, actor

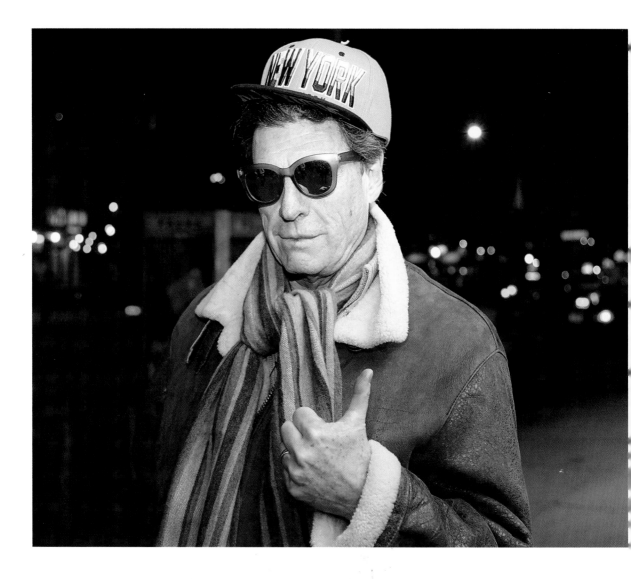

"I love the net."

Richard, teen

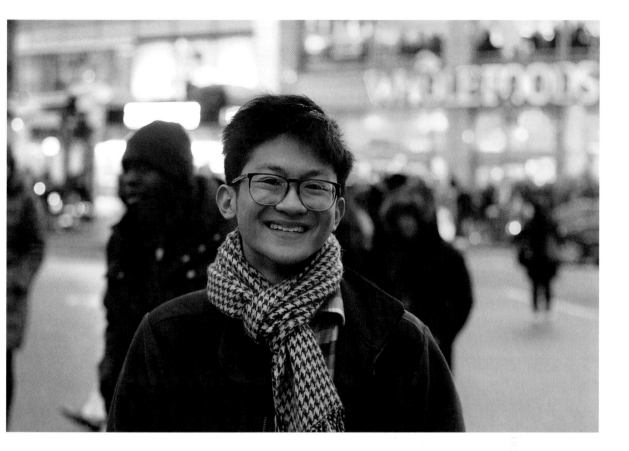

"I work for a start-up that's designing a pair of mittens made entirely out of recycled plastic bags. We were inspired by every single delivery guy in the city during the winter. We're calling them 'Handies.' We're still in our initial investment rounds, but I'm confident that in a few years I will have fulfilled my biggest dream: giving Handies to every single person in New York!"

Eric, founder of Handies LLC

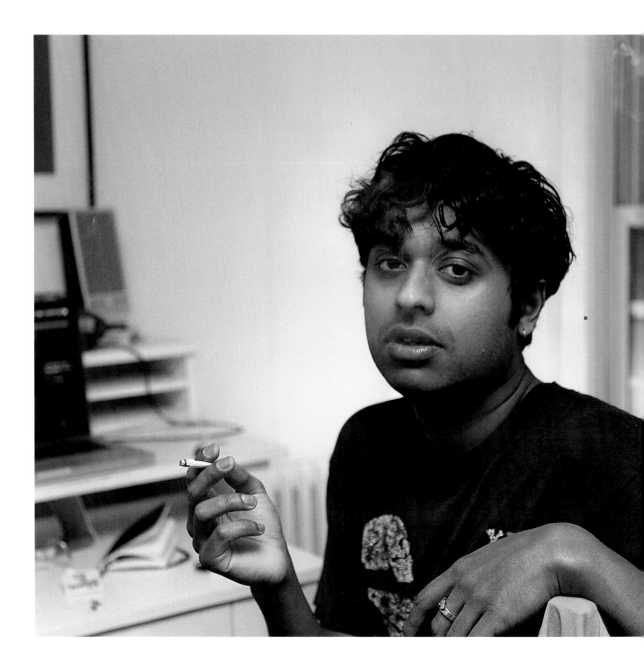

"I just realized that *ballerina* has the word *baller* in it."

Trevor, used to have a ponytail

"What happened to all the second-world countries, though?"

Trevor, owns nunchucks

"Crickets get no respect. Whenever people hear them they just call it silence."

Trevor, doesn't trust some dogs

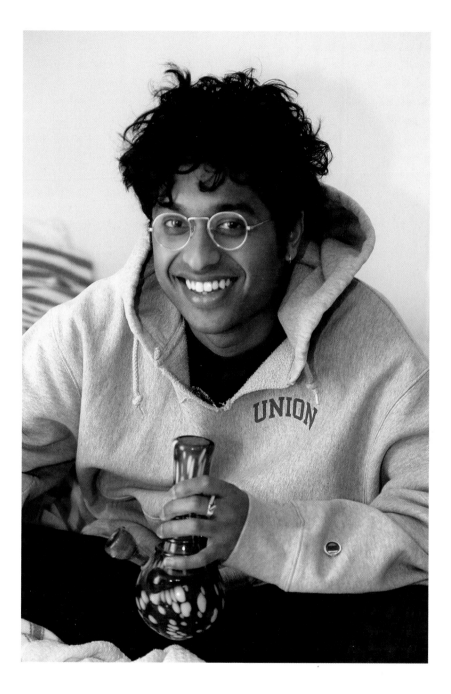

"J. K. Rowling should open a bowling alley called 'J. K. Bowling,' where people are just kidding about the fact that they are bowling."

Trevor, entrepreneur

"私は日本が大好き"[1]

Thomas, otaku

"The Israeli-Palestinian conflict is a complex, decades-long bloodbath of hate, but I'm *pretty* sure I can solve it with one all-caps Facebook comment."

John, coworker

"I decided to go to med school because my whole life I've just always wanted to help people have bigger, harder boobs."

Patton, med student

"I once read something on the IMDB message board for *The Notebook* that said girls at bars hate it when guys 'play games.' That's why I always make sure to keep it real and only use really honest pickup lines. For example, I'll go up to a girl and be like, 'Hey girl, even though I hate germs, I think your mouth would feel really good pressed against my mouth.' Or even, 'Hey girl, I'd like to simulate making a baby with you in your apartment.' And when I'm feeling really confident, I'll just say, 'You look a lot like my ex-girlfriend, but you're not. I like that.'"

Alexander, nurse

DATING

THE MOST COMMON ACTIVITIES FOR MILLENNIALS IN RELATIONSHIPS

DECIDING WHAT TO WATCH ON NETFLIX

WATCHING NETFLIX

WAITING TO GET UNDER THE HOT WATER WHEN SHOWERING TOGETHER

MOST POPULAR MILLENNIAL SEX POSITIONS

MISSIONARY

DOGGY STYLE

SEX IS A SIN

STATS

Ratio of Time Spent Searching for the Right Emoji to Describe Your Current Level of Arousal to Time Spent Getting to Know Each Other

20 to 1

Percentage of Millennials Who Think Their Partner's Pleasure Is Just as Important as Theirs

69

Most Common Methods of Breaking Up, in Order

1. Text message
2. Phone call
3. Voicemail from screened phone call
4. Gchat
5. Facebook status
6. Venmo comment
7. Whispering "it's over" into the wind
8. Morse code
9. In person

Most Common Place for Millennials to Have Sex

A bed

"People kept telling me to dress for the job I wanted."

Terence, currently living at home

ALEC MacDONALD AND CONNOR TOOLE

"I feel like kids these days are so disconnected from reality. They spend their entire day staring at a screen. It really makes me worry that they are missing out on their childhoods. When I was a kid we would actually *go outside* and use our *imagination*, you know? We'd climb trees, and pick up sticks, and make up our own little rules—like that you could only speak if you were holding this really big shell—and we'd run around the woods with our sticks and pretend we were warriors, and it was all so fun that eventually we would always decide to sharpen the sticks and, hooting and yelling, we'd chase this funny, chubby friend of ours around—who liked democracy too much—until he'd fall off a cliff and crack his skull open on a rock, and then things would get really wild and we'd have the most amazing time until the adults showed up and made us go home. I just don't want today's kids to miss out on that."

Jack, Time Warner customer service agent

"I let my four-year-old cousin pick the name of my dog. So meet 'Mommy and Daddy Won't Stop Fighting.'"

Dave, male nurse

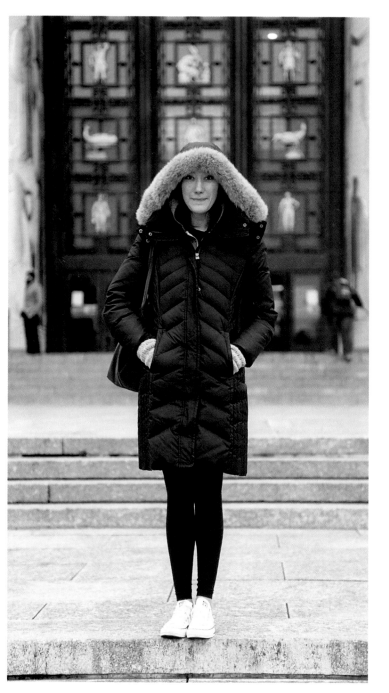

"I'm really politically minded. In October, I refuse to CC people on any emails in protest of Columbus Day."

Hallie, Native American ally

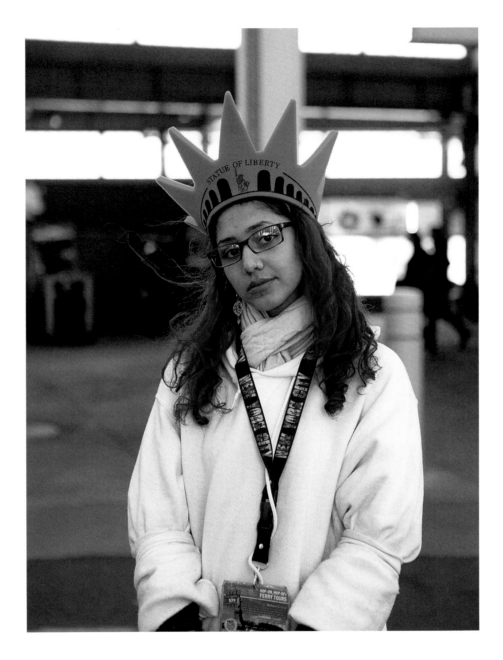

"The New York skyline is so iconic, the first thing I did when I got here was buy tickets to go to the top of the Empire State Building. I think it's a total rip-off. You can't even see the Empire State Building from up there."

Isabella, tourist

"I recently started a book club with some of my friends. I'm actually on my way there right now. Every month each person picks a book they bought for a class in college but never actually opened. This month we're reading *Slaughterhouse-Five*. I didn't actually have time to read it but I'm just going to talk about how well Vonnegut managed to truly capture the horrors of industrial farming."

Sarah, community garden manager

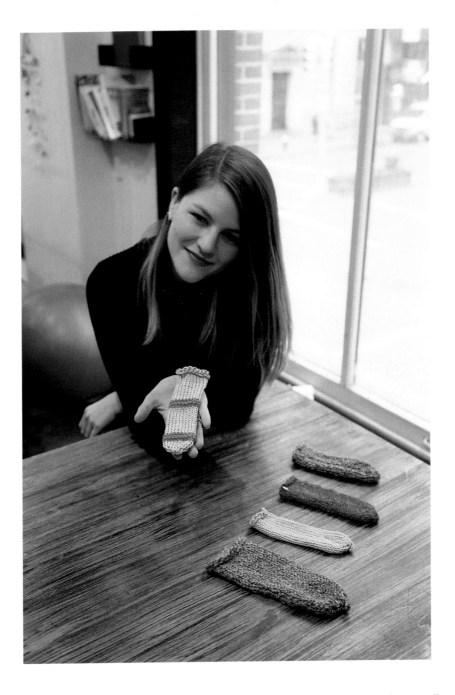

"I sell artisanal knit condoms on Etsy. This one is ribbed for *her* pleasure."

Jade, entrepreneur

Detail, www.Etsy.com/Jades-Handmade-Fucksocks

"I'm currently pioneering a revolutionary new genre called 'Newman Wave.' As you can probably guess from the name, it's heavily influenced by the New Wave movement. The only catch is that every single song only uses the notes from the *Seinfeld* bass riff."

Cody, podcast engineer

"I really, really love avocados, but I also really, really, really pride myself on eating local, so living in New York can be really, really, really, really, really hard sometimes."

Skyler, nutritionist

"I'm developing an app that lets people know when they're being *'that guy.'* You just put on this bracelet that shocks you with 250 volts of electricity whenever you say one of 2,000+ keywords/phrases aloud. The triggers include:

1. 'That's actually not what irony means.'
2. 'I only use Bing.'
3. 'It's not FRANKENSTEIN. It's Frankenstein's MONSTER.'
4. 'If you think about it, Kim Kardashian is a great businesswoman.'
5. 'Bitcoin'

If all goes well, the app should go live in December. Just in time for the people explaining that December 25 isn't actually Jesus's birthday."

Juliana, app developer

"People are so desperate to find ways to hack Tinder, but the secret to success isn't just listing *Serial* as an interest or posing with a more attractive friend in the hope people might think you're the hot one. It's about one thing and one thing only: parkour. Seriously. Just today I got a really steamy message that said '~ ~ ~ ♥ HEY THERE SEXY ♥ Would u LiKe to wiN a FREE pair of AUTHENTIC Naruto® Fingerless Gloves ALL COLORS AVAILABLE just enter to win & type code SPAMBOT69 for exclusive discounts on other hot PARKOUR products XOXOXO~ ~ ~.' I'm telling you, girls just can't get enough of modern Tarzans in the urban jungle."

Ron, cabdriver

"I was fired because my iPhone was too old."

Hallie, unemployed

"I was just one of the many people who moved to Murray Hill right after graduation. I tried to keep the college life going, but that's hard to do when bars charge $7 for Bud Light Platinum at happy hour. I spent so much money that I had to move to Brooklyn. I went to bed one night and woke up with this beard. I've tried shaving it, but it grows back whenever I go to sleep. It's like a hipster version of *The Santa Clause*."

Connor, cliché

"Yeah, I'm really into succulents these days. I just bought this cool new cactus at Whole Foods. Hope I don't overwater this one like the last four."

Julia, student

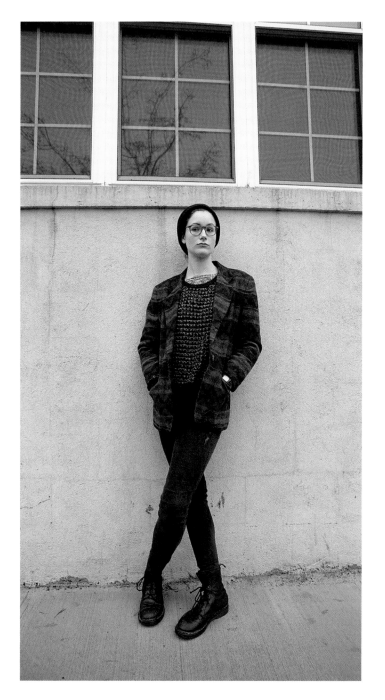

"I absolutely love street art. We're going to look at artists like Banksy and Shepard Fairey as the Monet and Van Gogh of our generation. I mean, it's incredibly exciting to be alive in a time and place where you can literally turn a corner and unexpectedly encounter a modern masterpiece on the side of, like, a hookah lounge that also rents adult videos on VHS. There's one super-prolific artist with an absolutely tireless work ethic who must spend his entire day drawing penises all over the city. It's incredible. I mean, I've seen his work on subway advertisements in Williamsburg, benches in Central Park, bathroom stalls in Astoria, and on every single phone booth in Staten Island. I really don't know how he does it. He's just that devoted to his craft."

Martha, gallery curator

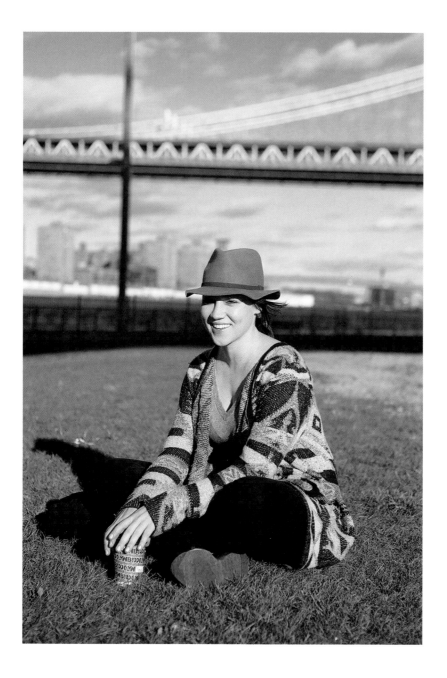

"I love cooking. And by 'cooking' I mean 'spreading an avocado on toast and taking a photograph of it by a window.'"

Camille, retail associate

"You ever have one of those nights where you just get really drunk and update your LinkedIn profile?"

Ryan, unemployed

"Imagine a strip club in the Nevada desert, staffed exclusively by the grown-up members of *The Mickey Mouse Club* who never got famous. That's how depressing being hungover at the DMV is."

Mary, bartender

HOW THEY THINK THEY SPEND THEIR MONEY ON FOOD

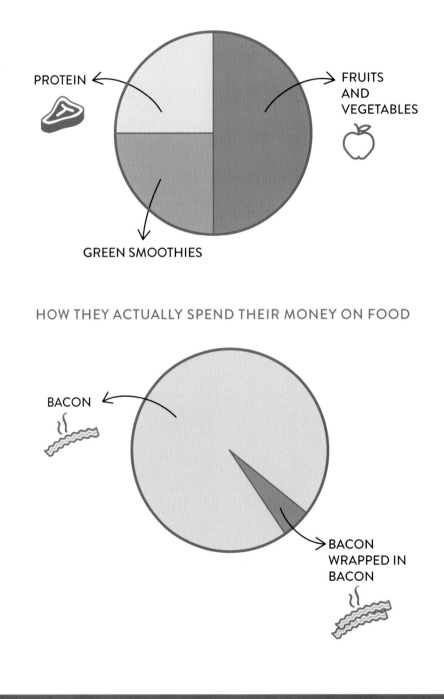

PROTEIN

FRUITS
AND
VEGETABLES

GREEN SMOOTHIES

HOW THEY ACTUALLY SPEND THEIR MONEY ON FOOD

BACON

BACON
WRAPPED IN
BACON

HOW THEY WOULD LIKE TO SPEND THEIR MONEY ON ALCOHOL

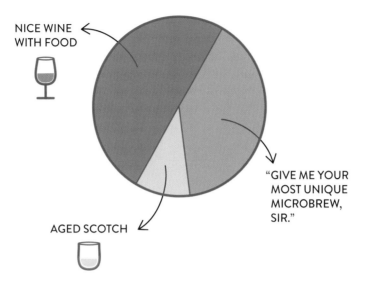

NICE WINE
WITH FOOD

"GIVE ME YOUR
MOST UNIQUE
MICROBREW,
SIR."

AGED SCOTCH

HOW THEY ACTUALLY SPEND THEIR MONEY ON ALCOHOL

"I'D LIKE
ONE MILLION
BEERS, PLEASE."

"I DON'T ALWAYS
DRINK BEER...BUT
WHEN I DO,
I THROW UP
ON MY DOG."

"GIVE ME A SHOT
OF YOUR FINEST
GUTTER POISON
BECAUSE THERE ARE
ASSHOLES TRYING
TO GET ME TO DANCE
AND I'D LIKE NOT TO
REMEMBER."

STUFF THAT ISN'T FOOD OR ALCOHOL

COFFEE

4 AM
UBER RIDES
WHICH INVOLVE
DRUNKENLY
ASKING THE
DRIVER "SO
HOW'S BUSINESS,
BRO?"

IMPORTANT MILLENNIAL MONEY-HAVING TIMELINE

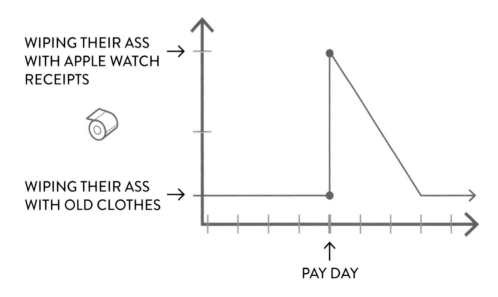

WIPING THEIR ASS
WITH APPLE WATCH
RECEIPTS →

WIPING THEIR ASS
WITH OLD CLOTHES →

PAY DAY

"I grew up in Alabama, so I consider myself incredibly fortunate to have had the chance to study abroad. It was amazing to have the opportunity to immerse myself in the cultural practices and traditions of such an exotic land. Honestly, I wouldn't be the person I am today if I hadn't spent that semester in New York City. They actually have 'gays' there. Just like in the movies! The whole experience was pretty surreal but incredibly illuminating. I learned so much! I will say that, after a while, I got homesick for my own people. In the end, I am super happy to come home—I can only listen to people discuss the environmental impact of fracking for so long before I really start craving a conversation about how the Confederate flag on my cousin's underwear is about Southern pride."

Annabelle, expanded her horizons

"Whenever I need to last longer during sex,
I just think about how few Twitter followers I have."

Samuel, sommelier

"Eric and I first kissed on my 25th birthday. The city was blue with dawn light, and we'd been up talking all night. He told me about how his father looked each morning on his way to work—tall, suited, thick black curls still wet from a scalding-hot shower. He told me about his silver-haired mother, who sang to him for hours once when he had a terrible fever as a child, his sweaty head lying in her lap. Then he told me I looked like a girl he saw in a dream long ago, and he kissed me. It was like nothing I'd ever felt before. From that night on we were inseparable. We slept entangled in each other's arms. When we'd moved in together, it wasn't weird or awkward. It was simple, meant to be. Once our shower broke and he washed my hair in the sink. That simple act made me feel so beloved. I remember the feeling of his hands, lathering conditioner into my hair, smelling of citrus. He supported me, comforted me, made me feel like I was living the life I'd always been quietly searching for. Then he broke up with me for a girl with a PhD and really big boobs. But don't worry. I'm totally fine. Seriously. I just got bangs."

Lucy, has bangs

"I love living in New York, but it can be pretty stressful. There are just so many things you have to worry about, like 'Will today will be the day a Lovecraftian monster from the darkest corner of my nightmares rises from its slumber below the East River and makes mankind pay for its countless sins by laying waste to its most iconic metropolis?' and 'Is the L running?' It's really tough dealing with that kind of uncertainty."

Neil, carpenter

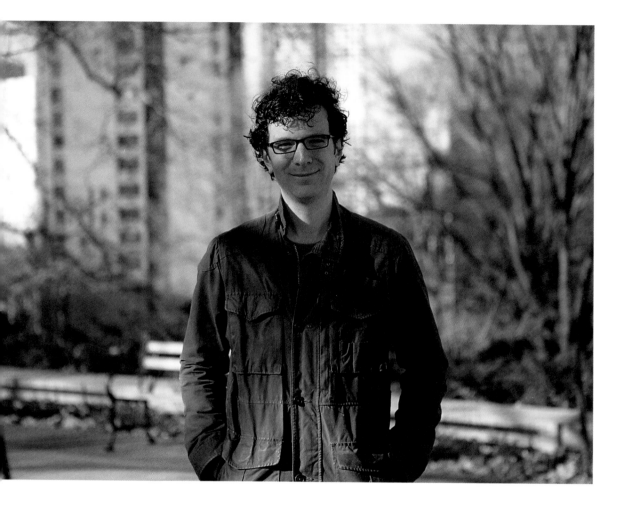

"A lot of my friends do improv—it's great! Whenever I need to move, I just ask them for help. They can never say no! . . . Sorry. I made all of that up. I actually do improv at UCB East at midnight on Thursdays. You should come check my team out—we're called the Obamacare Bears."

Noah, had a joke rejected by "Weekend Update" in 2011

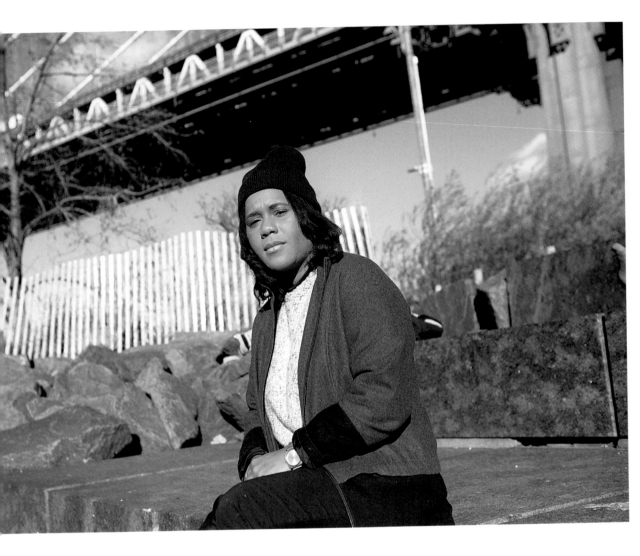

"I hate walking around the city in the summer. I know that those random drops of liquid that hit you on the head are probably just from an air conditioner, but I have a hard time convincing myself that it's not actually from someone peeing out of a helicopter."

Denise, paralegal

"I have a theory that every cabdriver with a Bluetooth headset is on the same conference call about the best undiscovered places around the city to do parkour. That's why they're always whispering—they want to keep the best spots for themselves."

Tricia, dental hygienist

"I'm currently working on a few television pilots."

What are they called?

"The first is *But Where's My Boyfriend?*, the second is *Why Would We Go to Any Other Bar or Coffee Shop?*, and the last is *Who Killed the Sex Worker?* They're just working titles."

Derek, aspiring writer

"My boyfriend and I are really into phone sex—we each scroll through Instagram on our phones while I ride him until one of us gets bored."

Lindsey, autopsy technician

134 ALEC MacDONALD AND CONNOR TOOLE

"It's really sad to see how much the city has changed since I was younger. Whatever happened to the real New York? I almost feel bad for anyone who decides to live here now. These faux New Yorkers will never understand how authentically bohemian and vibrant this place used to be eleven months ago, when I moved here."

Alexa, hostess

"I had a girlfriend who was absolutely obsessed with *Eternal Sunshine of the Spotless Mind*. One night she mentioned she thought it would be really romantic for the two us to lie together on the Charles and stare at the stars like Joel and Clem. I told her we should go right then and there. I just wish I had known the Charles was a river in Massachusetts and not a creek in some random town on Long Island. It took us five fucking hours to get there, and we didn't even start in Montauk. The worst part? When we finally arrived the river wasn't even frozen. I blamed global warming. She blamed me for forgetting to remind her it was only October. We just so happened to break up a few weeks later. Part of me wishes I could just forget that time in my life."

Creighton, Kickstarter speculator

TRANSPORTATION

CORRELATION BETWEEN NUMBER OF DRINKS PER HOUR AND THE HIGHEST ACCEPTABLE SURGE PRICE

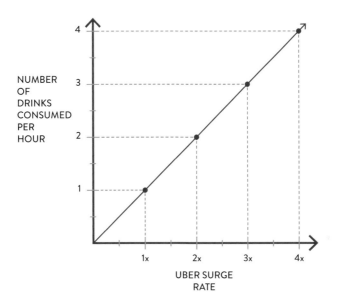

THE EXACT CHEMICAL COMPOSITION OF "THAT SUBWAY SMELL"

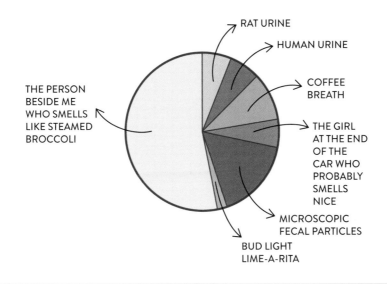

STATS

Average Number of Times a Millennial on Their Way to Work Will See a Man Wearing a Suit and a Backpack Riding a Razor Scooter Per Week

4.3

Songs Most Commonly Used by Subway Performers to Drown Out the Music in The Headphones of Commuters

1. "Stand by Me"
2. "Amazing Grace"
3. "Over the Rainbow"
4. Loud Bible shouting

Most Effective Strategy to Ensure One Is Ignored by People on the Subway While Commuting

Homelessness

Blocks Collectively Walked by Millennials Each Year to an ATM Because of a Cash-Only Bar

12.6 million

Amount of Time It Would Take for the Millennium Falcon (at Cruising Speed) to Travel the Same Distance

965 hours (5 parsecs)

Number of Times Approaching a Girl on Public Transportation Has Ended in Marriage

1 (Mark Friedman, 29)

Chances That an Owner of an Expensive Fixed-Gear Bicycle Will Mention It in Any Given Conversation

1 in 3

"Whole Foods is the best. It's incredible, I can get avocados from Mexico, salmon from Alaska, pasta from Tuscany, and pretentious people from the seventh circle of hell."

Stacey, assistant manager at Trader Joe's

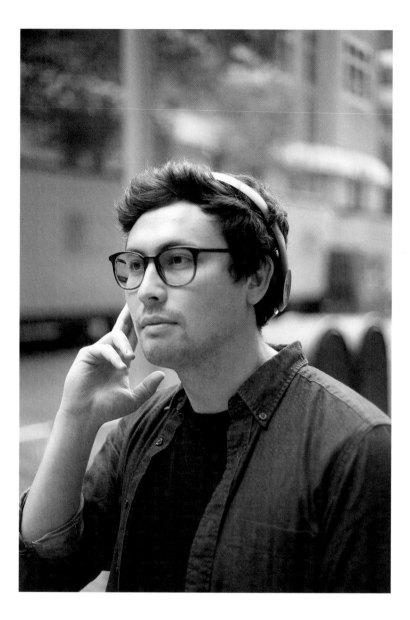

"I'm a successful club DJ, so music is literally my life. What's my favorite kind? Well, honestly, I love all music. Music is humanity's common language. Music is what helps us express our innermost selves. Music is what sets us apart from the animals. But I guess if I had to pick my favorite genre, I'd probably have to go with 'Songs About How Great Butts Are.'"

Dmitri, bartender

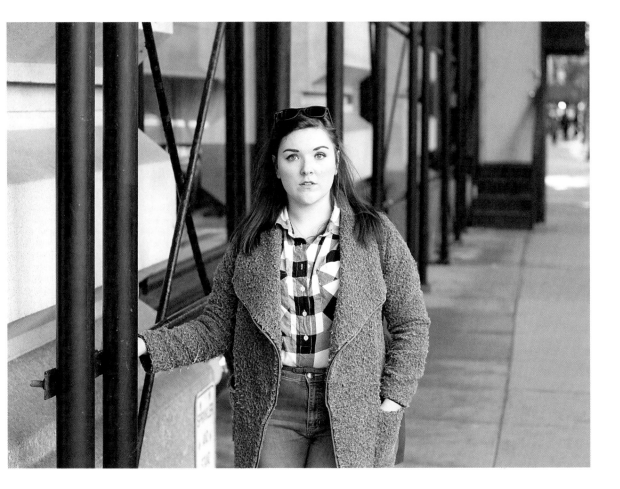

"I went through a phase where I was really into Instagram accounts with guys following whatever the new trend was. Hot guys with beards, hot guys lifting heavy objects, hot guys holding puppies with three legs—I basically stopped watching porn because I had everything I needed in a conveniently scrollable format. It took me a while to realize I was just into hot guys doing anything."

Lauren, beauty editor

"I absolutely love being single in NYC. I don't need to be in a relationship in order to be happy. I mean sure, I can get lonely once in awhile. And yes, occasionally I will get a bit dehydrated from excessive crying and only drinking rosé. And okay, sometimes I do order flowers from the deli just so the delivery guy has to hand them to me like he came to my house to tell me he still loves me. And fine, there are of course nights where I microwave a pillow so that I can finally cuddle with something warm for once. But, honestly, I'm super happy being single. It's just like *Sex and the City*."

Kari, advice columnist

"I'm a proud supporter of the Second Amendment."

Buck, Republican

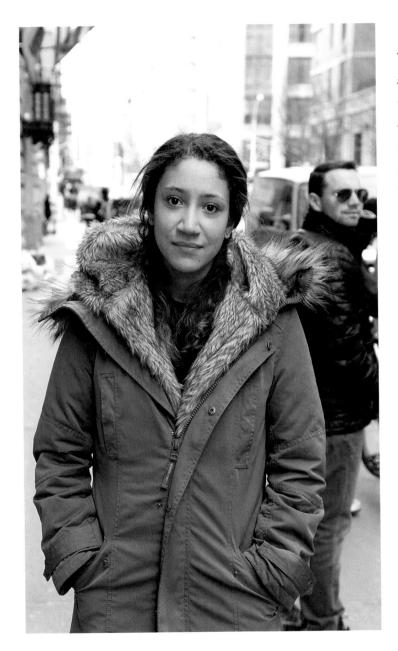

"Everything my parents know about the city they learned from watching people get decapitated on *CSI: NY*. So they were pretty relieved when I told them that I had found a cozy studio on the Upper East Side, a block away from Central Park. I can't imagine how horrified they'd be if they ever found out that I actually share a basement apartment in Bushwick with four Ukrainian DJs—all named Ivan. I have to book the same Airbnb in Manhattan whenever my parents come to visit me. The only catch is that in order to afford my fake room I've had to Airbnb my actual room. So now I just sleep in the living room on a pile of the Ivans' spare tracksuits. It's surprisingly comfortable, but it smells like ecstasy and borscht."

Emily, copywriter

"Sure, I'd love to take a picture! When do you want to do it? Right now? Cool, let me just send you a Google Calendar invite so we don't forget."

Dani, assistant production assistant

"There's nothing I love more than going out in the city. Some of my friends complain about having to pay a cover, but it's totally worth it. I just don't think you can put a price on the opportunity to party in an abandoned mannequin factory that's been converted into the world's largest ball pit. Plus they've already shown that they are perfectly willing to pay money they don't have in order to binge drink with strangers in a dark room and hope nobody starts grinding on their leg. It was called college."

Marie, chemical engineer

"I'm really into photobombing."

Ivan, DJ

"It was so hot last night that I had to go to a bar because my apartment doesn't have AC. They had these really delicious blue margaritas so I don't really remember going to bed, but when I woke up this morning my mattress was literally SOAKED with sweat. At least I think it was sweat. What does it mean when your sweat is yellow? Do I need more vitamin K?"

Elle, brunch critic

"Plaid."

Waylan, plaid

"If there is one thing I've learned as an adult, it is that there is *way* less hanging out around the water cooler than I was led to believe. I've been posted up here for 20 minutes and the only gossip I've heard is 'Susan from marketing likes anal'—and I had to whisper that to the unpaid intern."

Susan, from marketing

"Political correctness is destroying my stand-up career. My entire sense of humor was dependent upon people finding it funny when I called every bad thing 'gay' or 'retarded' and shouting my catchphrase: 'THESE BITCHES BE CRAZY!' What am I supposed to do now? At this point, the only person who still thinks I'm funny is my grandmother. And all she does is cook meatloaf and call JFK 'that Catholic homo who was big with the Jews.' Yeah. That bitch be crazy! The doctors say it's dementia."

Jeff, comedian and assistant floor manager at Foot Locker

"I buy passes for music festivals and post them on Instagram before reselling them so people think I have a social life. I've actually never been to one. Someone asked me why I never post pictures of the actual festival and I said, 'I leave my camera at home because reality shouldn't be viewed through a lens.'"

Alexis, marine biologist

"One of my favorite things about living in New York is that you can be watching a movie or a television show and suddenly recognize something in the background. I was watching an episode of *Castle* and realized one of the curb stompings happened right outside my favorite Swedish espresso bar. It really made me crave one of their super-crunchy biscotti!"

Charlotte, youth pastor

"A lot of bars near my apartment have rainbow flag stickers in the window, which I just think is really inspiring. The only downside is that it can be really hard to figure out what places are *actually* gay bars and which ones are just regular. I went to one place last week and it took me forever to figure out the vibe. I was there for three hours and not a single guy there tried to hit on me, so I'm pretty sure The Brazen Cock was just a regular bar."

Reggie, tolerant

"Everyone who knows me that I'm only wearing this ironic T-shirt ironically. I would never wear something like this normally."

Ike, Major League Gamer

"My mom is always yelling at me for not teaching her how to use technology. And she's right. I don't. Whenever I help her, I instantly regret it. I taught her to use Facebook a couple years ago, and now all she does is comment 'U GUYS WERE SO GOOD TOGETHER' on old pictures of me and my ex. Then I showed her how to Skype, and the only time she uses it is when she wants to show me a photograph on her phone of Aunt Carol's neck cyst. I swore I would never help her again, but then she threatened to stop paying my cable if I didn't set up Hotmail on her iPhone. Now she won't stop forwarding me emails titled 'Just thought you should know' full of grainy photos of disfigured fetuses. Next time she asks for help, I don't care if Siri is trying to convince her to kidnap Raven-Symoné—I'm going to tell her to figure it out herself."

Heidi, programmer

"I'm the youngest person at my marketing firm, which means I'm the person my bosses instinctively turn to whenever a client wants to appeal to millennials. The other day, a certain automobile manufacturer asked us to figure out the best way to make my generation think their cars are—and I swear to god they actually used these words—'the bomb.' I jokingly told them they should just pay a popular rapper to name-drop their brand in a song and, amazingly, they actually ran with it. So if you ever hear Wiz Khalifa talking about getting road head in his hotboxed Chrysler Town & Country, yeah, that's because of me."

Mark, chief vice executive director of marketing

"I can't watch sitcoms that take place in New York City anymore. I'm sorry, but I find it kind of hard to sympathize with the struggles of a part-time waitress when she lives in an apartment that's bigger than the warehouse where Ashton Kutcher stores his trucker hat collection. The first and last episode of *Friends* should have been called 'The One Where Chandler and Joey Stop Being Friends After Joey Can't Come Up with Enough Money to Cover the Security Deposit.'"

Olivia, editor

FILM AND TELEVISION

MILLENNIALS AND MURDER TELEVISION

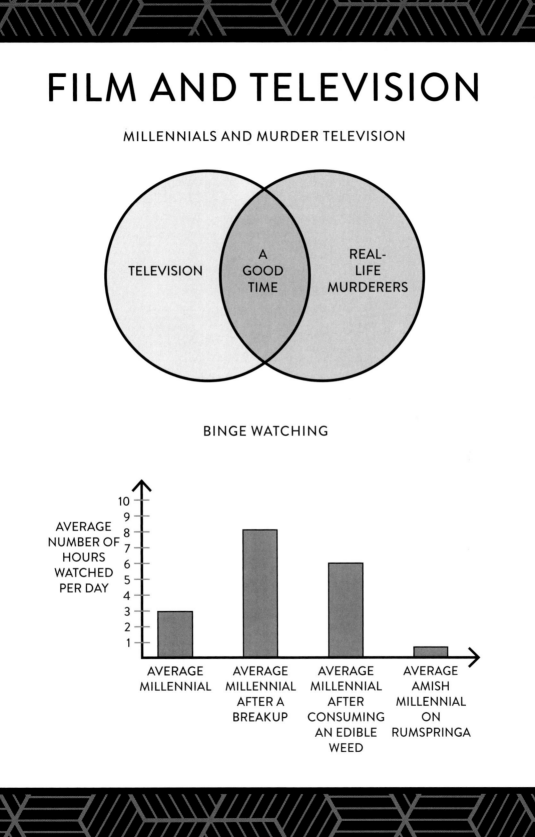

TELEVISION

A GOOD TIME

REAL-LIFE MURDERERS

BINGE WATCHING

AVERAGE NUMBER OF HOURS WATCHED PER DAY

10
9
8
7
6
5
4
3
2
1

AVERAGE MILLENNIAL

AVERAGE MILLENNIAL AFTER A BREAKUP

AVERAGE MILLENNIAL AFTER CONSUMING AN EDIBLE WEED

AVERAGE AMISH MILLENNIAL ON RUMSPRINGA

HOW TO BE A GOOD FATHER, ACCORDING TO TELEVISION

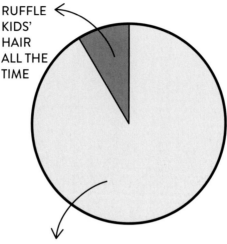

RUFFLE KIDS' HAIR ALL THE TIME

BE BAD AT HOUSEHOLD CHORES AND LET YOUR HOT ANGRY WIFE SHOUT AT YOU

STATS

Most Popular Movie Genres Among Millennials
1. Muscular Men Driving Muscle Cars
2. Adaptations of Stuff I Got Bullied for Liking in High School
3. Anemic Immortals Dry Humping
4. Liam Neeson Moving Surprisingly Well for His Age
5. Sequels

Average Degree of Separation Between a Millennial and the Person (or Persons) Who Pays for the Netflix Account They Use
3.1

Number of People Who Actually Pay for Their Own Netflix Account Who Are Viciously Attacked by a Swarm of Seagulls Annually
27%

Most Common Source of Illicit Accounts
1. Ex's parent
2. Dead relative whose account was never canceled
3. Cousin of your college roommate's girlfriend's childhood neighbor, Cheryl

World Record for Binge Watching
23 hours (Second Lieutenant Mark Friedman, drone operator, United States Air Force)

DVDs Owned That Are Now Available for Free Online
87%

Millennials Who Can Successfully Differentiate Between Bill Pullman and Bill Paxton
1 in 5

Age at Which Millennials Start Being Quietly Judged for Their Lingering Obsession with Disney Movies
22

Average Number of Films Mark Ruffalo Appears in Annually
2.125

"People these days simply don't cherish the wisdom of our elders like we should. In 1923, my grandfather arrived in New York after an eight-week voyage from Ireland. He lived in the city his entire life, and even though he passed away when I was ten, he made sure to pass down some of the valuable lessons that he learned before he died—sage advice like 'The hot dog stand on 54th Street sells loosies for a quarter' and 'Always tip your barkeep, even if he's a Protestant.' There's a reason they're called the Greatest Generation."

Josh, manager at Foot Locker

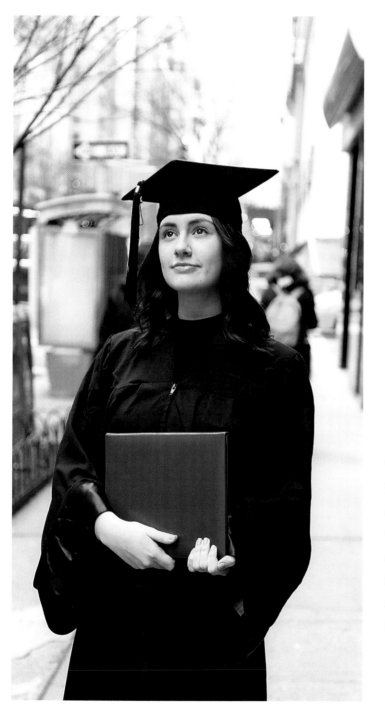

"Ah, I actually graduated! I can't believe it! It's been a long, difficult, and humbling journey. And I just want to say that I could *never* have accomplished any of this without the love and support of my family, my friends, and my Adderall. I am forever in their debt. And in debt."

Rebecca, figuring everything out

"It's disgusting how so many people just completely ignore the homeless. I'm not like that. Whether it's offering to set up a Facebook event for their birthday, or explaining the plot of the first season of *Serial*, I always do my best to help. Yesterday I gave a homeless guy one of my favorite vinyl records. He looked confused when I handed it to him, so I explained that the album really helped me get through a dark place once. He said that he didn't have a record player, and asked if I had any food or money instead. I shook my head, put a tissued hand on his filthy shoulder, and said 'This is food for your soul.'"

Max, co-op inventory manager

Why do you like going to Comic Con?

"Because I get to meet people who are passionate about the same stuff as me."

Which is?

"Alliteration."

Lauren, linguist

"They say we are in the golden age of television, and I, for one, think that's so true. I watch a ton of TV, but if I had to pick, I'd say my favorite shows are the ones about people who have a serious psychological problem that compels them to fill their home with trash and live in miserable, tragic squalor, losing their friends and self-respect in the process. I love *The Bachelor*!"

Diana, clinical psychologist

"I just started a support group called Functioning Alcoholics Anonymous. It's just like AA, only the rules are designed to encourage moderation to avoid letting alcohol take over your life. They include:

1. Water bottles aren't just for water.
2. Only drink on days that contain the letter *s*.
3. You can't be an alcoholic if you only drink white wine.
4. Bottomless Bloody Marys count as one drink.

We give out chips too. I don't know what I would do without having mine on me at all times. It's really important to always have something in your stomach before you start drinking."

Patricia, alcoholic

"I'm a freelancer who designs those chalkboard displays at organic grocery stores in the city, so the world is basically my office. There's nothing I love more than working outside—the sun hitting your hair, the grass between your toes, the total inability to see anything on your screen. It's just perfect."

Sage, organic grocery store chalkboard display designer

"I hate being put in the friend zone. I like to think I'm a nice guy, but this one girl I know flat-out refuses to be my girlfriend. It doesn't make any sense. I hold doors for her, like, all of the time, and I tell her she doesn't look fat in dresses—which should at least make us 'friends who hug sometimes.' Plus, I send her feminist Facebook articles, which any reasonable person would assume means I am entitled to some boob contact. I even listened to her being all sad about her grandfather dying for like a full 25 minutes last week. Still nothing. That's got to at least be worth a hand job, right? Girls are so crazy."

Lawrence, sells handmade Japanese body pillows on Etsy

"Long Island is the new Brooklyn."

Zelda, performance artist

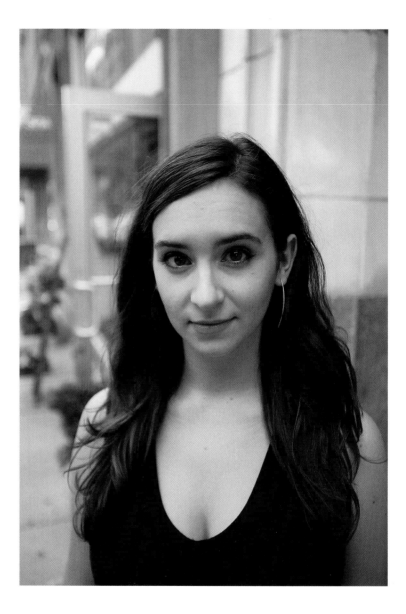

"I have gone on every single cleanse I can find to try to lose weight. I've tried them all—the Master Cleanse, the Prune Juice Cleanse, the Coffee Enema Cleanse, the Ramadan Cleanse—but I just couldn't keep the pounds off once I started eating normally again. I finally went on the Indonesian Pebble Cleanse and lost fifteen pounds in a single day! The doctors said they had to remove seven feet of my small intestine, but I've never felt healthier."

Summer, impersonal trainer

"I was really tired of spending my entire commute getting way too intimate with total strangers, so I finally decided to buy a bike and start riding it to my office. Well, at least that was my plan initially. On the first day I made it three blocks from my apartment before it dawned on me that I'm genuinely terrified of riding a bike in New York City. That's not to say it hasn't helped me get healthier though—now all I have to do is *think* about navigating the streets of Manhattan and my heart rate immediately skyrockets! I barely have to exercise! It's been a great investment."

Vanessa, afraid of death

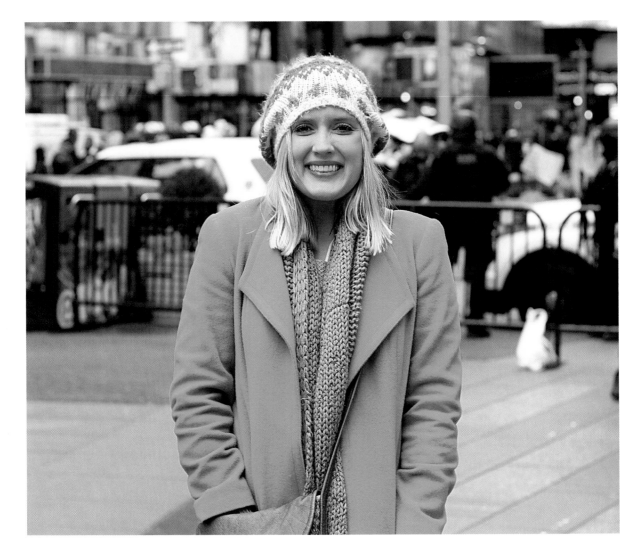

"My birthday has always been my favorite day of the year. When I was a kid, I threw temper tantrums because I couldn't deal with not being the center of attention the other 364 days of the year. When I went to college, one of my sorority sisters introduced me to the concept of 'birthday week.' That was all I needed for a couple of years, but then I needed something more. After I graduated I started celebrating my 'birthday month,' but even that wasn't fulfilling enough. I just decided to start celebrating my 'birthday year.' Now I have a birthday every day. My doctor says I have cirrhosis."

Nicole, wedding planner

"The first few months I lived here I didn't know anything about the city—I just knew what areas to avoid based on the neighborhoods I heard name-dropped by my favorite rappers."

Paul, brand ambassador

"I feel like it's been forever since the last time I went to Fashion Week. What's my personal style? Well, you can basically describe my current look as 'It's 1898 and I, a humble hemp farmer, am set to marry the daughter of a rich industrialist. She may be prettier than Annie Oakley and sweeter than a slice of watermelon on a warm summer's day, but I just can't bring myself to love her. So I decide to just drop it all and go work on the railroad—where a hard day's work is met with a day's honest wage, and the men drink black coffee, tell stories around the fire each night, and sleep under a canopy of a million flickering stars.' But if that description is too long I guess you can just write 'Amish chic.'"

Hunter, Tumblr model

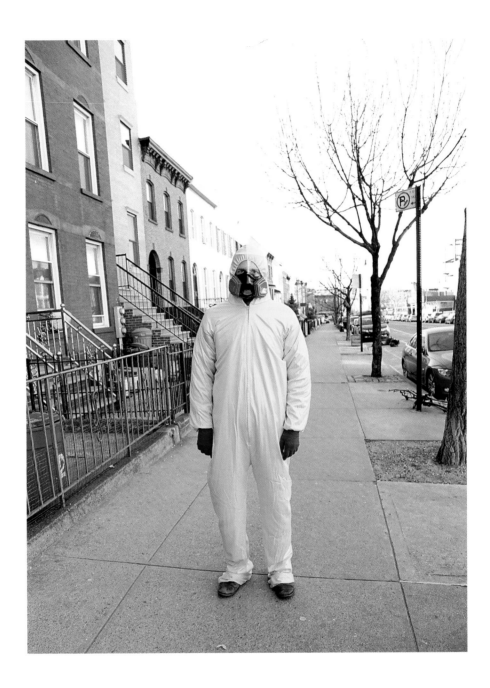

"I just really don't want to go viral."

Kyle, germaphobe

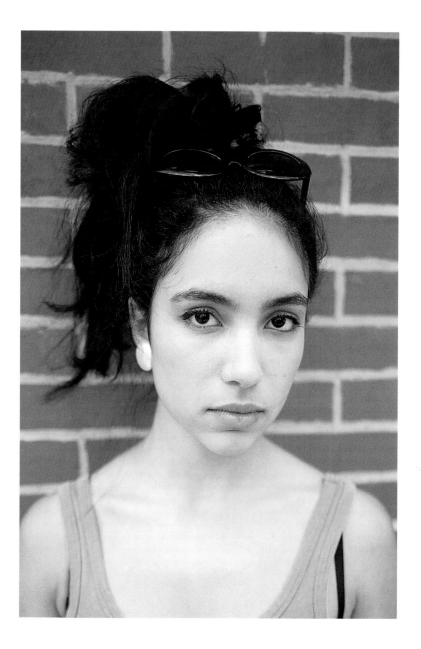

"I wrote 'Happy birthday' on someone's Facebook wall today. Just the words *happy* and *birth-day*. No wordplay. No fun spelling. No gifs. Nothing. I guess I've officially become an adult."

Alli, adult

"Religion has been responsible for so many problems over the centuries. I mean, there's *nothing* worse than people trying to *impose* their belief system on others. That's why, whenever I'm at a party, I always find at least one Christian to have a free exchange of ideas with. I mean, I just feel like it is my duty to help them understand how having an unshakable faith in a particular ethos is a close-minded way to live and that if they don't become atheists like me, they're fucking idiots."

Bruce, aspiring leather jacket owner

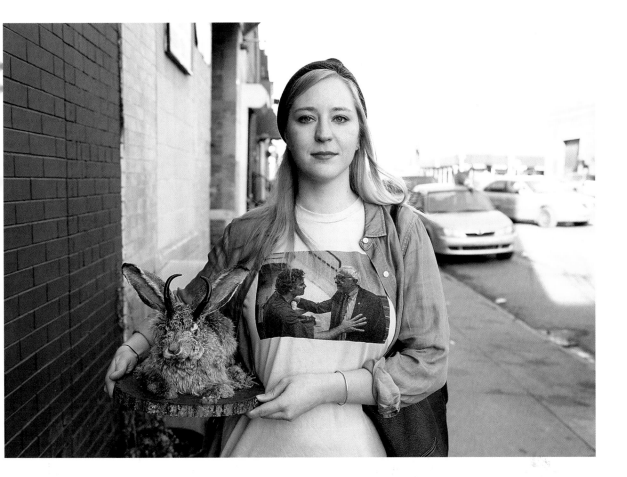

"It used to be impossible to walk down the block in my neighborhood without running into some super-trendy boutique. When I first moved here, I lived above a miniature-cupcake bakery that was next to a non-kosher frozen yogurt place located directly across the street from a Vietnamese bubble shop—they didn't sell bubble tea, just different variations of imported bubble soap. Sadly, they've all closed over the past couple of years. I'm not sure why—opening a store specializing in hyper-niche foodstuffs seems like a fantastic business model. That's what drove me to open a store that exclusively sells expired Twinkies that were manufactured before the Hostess bankruptcy."

Chrysanthemum, trust fund recipient

"I was evicted from my apartment after I found out my roommate had been using every single one of my rent checks to finance the artisanal Jell-O shot delivery operation he was running from his bedroom. We found out when he was arrested while trying to sneak into our building with a horse carcass."

Clarissa, florist

"I think every single college should make you take a class where they teach you what you're supposed to do in your apartment when another person is installing your modem."

Darya, public relations specialist

"I love working in the service industry. When I received my bachelor's degree in psychology, I couldn't have *dreamt* of a better way to study the darkest corners of the human condition than listening to a bunch of USC grads at brunch discuss the heat and magnitude of their beer shits. It's like my own personal Stanford Prison Experiment every weekend. You never know when they're going to turn on you."

Nathaniel, waiter

"I write articles for the internet."

What was the last thing you wrote?

"Oh, it was an article called '10 Beautiful Pictures of Disney Princesses Busy Photoshopping Disney Princesses for Disney Princess Listicles.'"

Rachel, received an MA in journalism

"Why are there no female delivery guys?"

Grant, livestreamer

"The internet has had a profound effect on our way of life, and our laws should keep pace with the rapid changes in culture and technology. For example, you should be allowed to press charges against anyone who tries to hold your phone when you go to show them something on it. Like, I'm just trying to share this picture of Joe Biden eating ice cream, not explain why I have 183 toilet selfies saved to my camera roll."

Seth, intern responsible for Doritos Locos Tacos

"I just love watching people people watching."

Sheryl, legal aide

FOOD

HOW MILLENNIALS TIP AT COFFEE SHOPS

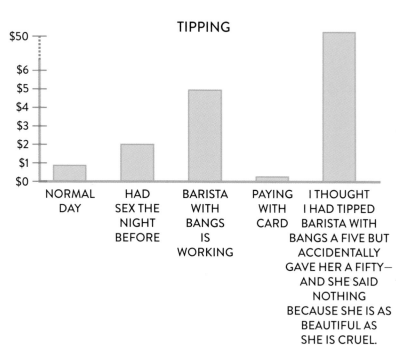

TIPPING

$50	
$6	
$5	
$4	
$3	
$2	
$1	
$0	

NORMAL DAY | HAD SEX THE NIGHT BEFORE | BARISTA WITH BANGS IS WORKING | PAYING WITH CARD | I THOUGHT I HAD TIPPED BARISTA WITH BANGS A FIVE BUT ACCIDENTALLY GAVE HER A FIFTY— AND SHE SAID NOTHING BECAUSE SHE IS AS BEAUTIFUL AS SHE IS CRUEL.

STATS

Average Number Of Plastic Grocery Bags Underneath the Sink
 16.3

Top Uses for Plastic Bags Under Sink
 1. Bringing lunch to work
 2. Autoerotic asphyxiation
 3. *American Beauty* cosplay

Annual Reported Assaults on Trader Joe's Employees by Whole Foods Team Members
 3.8

Number of Times the Average Millennial Will Pay Extra for Guacamole in Their Lifetime
 1,347

Number of Times the Average Millennial Will Utter the Phrase "I Only Smoke When I'm Drunk" in Their Lifetime
 1,347

Optimal Number of Slices of Domino's Pizza Needed to Satisfy Marijuana-Induced Cravings
 3.14159

Number of "Female Delivery Guys" Currently Working in New York
 36

Number of Times a Millennial Will Google the Name of a Dish When Ordering Indian Cuisine on Seamless
 2.7

Number of Millennials Who Will Be Banned Each Year from Ordering Chinese Food Because They Fell Asleep After Ordering Delivery Past 1 A.M.
 1,237

Most Popular Types of Brunch Dishes Among Millennials
 1. A combination of grease and carbs to soak up the alcohol
 2. A salad that doesn't cancel out the Chinese they ate at 2 a.m.
 3. Four Bloody Marys
 4. Something with avocado (for health purposes)
 5. Anything with "powdered sugar" in the description
 6. Other people's fries

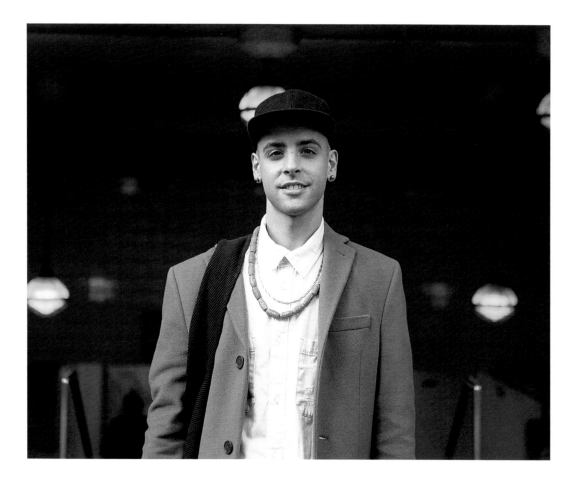

"Do you want to know the secret to my success? It's simple. First, I updated my social media bios to include the words *entrepreneur* or *CEO* so people knew I was serious. Next, I needed a name for my company. So I sat down with a warm cup of coffee and a full vape and tried to think of a something a Pokémon would be called. That's how Yawaz was born. Now look, Yawaz isn't just a company. Yawaz is a state of mind. Everyone is talking about Yawaz. People ask me how I could afford to start a company, and the answer is simple: commitment and hard work. Also, Yawaz doesn't necessarily provide any specific 'service,' per se—which really helps keeps costs down. If anyone asks what Yawaz does, I just keep saying the words *metrics* and *data flow* and *global analytics* until I have intimidated them into investing."

Jason, founder, CEO, and head visionary, Yawaz

ALEC MacDONALD AND CONNOR TOOLE

"Don't tell anyone, but I've been in hiding for months. I legally changed my name and destroyed my cellphone, worried that they could track me with the GPS. I don't use credit cards and never speak of my past. Leaving my life was painful, but I had no choice. All my friends started doing CrossFit. I dunno, I just had to get out of there."

Stephanie, ex-botanist

"The other day I realized that when my grandfather was my age, the only #SquadGoals he had to worry about were infiltrating an incredibly complex network of tunnels outside of Saigon and hoping his fellow soldiers were able to pull the trigger faster than any of the Vietcong they happened to encounter while traversing that booby-trapped labyrinth under the jungle."

Andrea, cam-girl

"Getting to pick between flying in or out of JFK, Newark, and LaGuardia is like deciding what kind of STD to contract. Newark is chlamydia."

Madeline, tour guide

What are you writing?

"Well, right now I'm working on a screenplay for this romantic comedy where, you see, the man is a lovable but *hopelessly lazy* high-powered corporate lawyer, and the girl is a career-obsessed, but *very cold* part-time bike messenger."

Sam, successful writer

"This is what happens whenever
I remember that Princess Diana is still dead."

Mellissa, beauty editor

"What people don't realize is that this country has become so ridiculously polarized that when you vote for president you aren't really voting for a person you're voting for a party except that this party isn't fun at all this party is a terrible party where there is like not enough beer and all the snacks at the party are really salty so you're just thirsty all the time like you're in the fucking desert or something like *Lawrence of Arabia* which is my all-time favorite movie even though it's completely racist and longer than Bigfoot's dick which I guess now that I think about it isn't really that long at all because it's invisible since Bigfoot doesn't exist although I dunno sometimes I feel like science is just as reliant on faith as religions and superstitions are so who knows maybe Bigfoot does exist and if he does exist then he definitely would have a really big not-at-all-invisible dick and honestly I think both Republicans and Democrats could agree on that."

Gabriel, undecided voter

"I said GIVE ME YOUR FUCKING MONEY!"

Unknown, entrepreneur

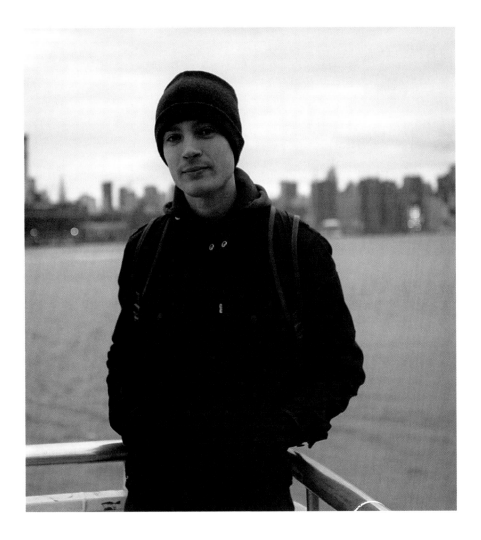

"I've traveled all over the planet—Italy, Israel, Staten Island—and even though I know it's a cliché, I honestly haven't been to a single city that can come close to matching the quality of the pizza and bagels you can find on almost every block here. There's just something about NYC that you really can't replicate anywhere else. Some people say the secret is the tap water, but I think it's our tendency to ignore the aspects of the metropolis that are sorely lacking compared to other locales in favor of magnifying and hyperbolizing our more valued assets and qualities to reinforce the air of superiority that makes us, without question, the greatest city in the world."

Dominic, off-Broadway usher

"I'd never been to New York before I relocated here for my job. It took me a while to get settled in, but once I did, I decided to set aside a weekend to do all of the things tourists do when they visit the city. It was great. I paid the full price of admission at the Metropolitan Museum of Art, felt genuinely compassionate for a homeless person on the subway, and had one of the best meals of my life at the Applebee's in Times Square before going to Canal Street and following a guy wearing a Bluetooth earpiece down a dark alley for a '100% real Rolex,' only to find myself playing Russian roulette with a Ukrainian guy named Ivan, whose organless corpse I later had to help dump out of a boat, 400 feet from Ellis Island. I'd never seen the Statue of Liberty so up close!"

Ellen, production assistant

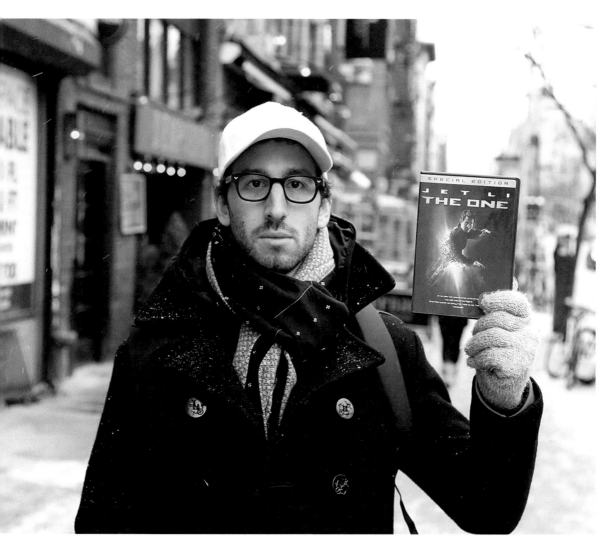

"Millennials are always talking about how hard it is for them to find *The One*. But, like, it's on Amazon."

Christopher, has read Jackie Chan's autobiography I Am Jackie Chan

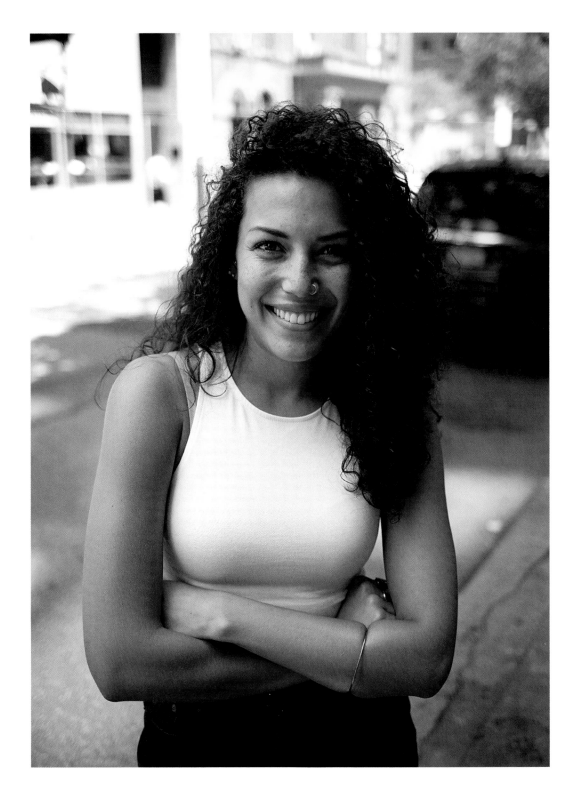

"I was searching for a more permanent place to live after subletting for a few months and found an amazing studio on the Upper East Side. The realtor told me I needed a month's rent, a security deposit, and a newborn kitten. I thought it was kind of an odd request, but I really didn't want to lose the place so I brought everything to her office the next morning. She ate the cat. She ate it and made me sign the contract in blood. I absolutely love the apartment."

Monica, veterinary assistant

"One of the toughest parts of graduating was realizing I couldn't be a real person and still drink like a college student. It didn't take me long to realize the importance of setting limits for myself. One morning I was so hungover at work that I puked in my boss's decorative Zen garden. He asked me if there was anything wrong, and, in a panic, I told him the first thing that came to mind: morning sickness. Now, he won't stop asking me what I'm going to name my 'little nugget.' I'm having a miscarriage next week."

Isabella, kindergarten teacher

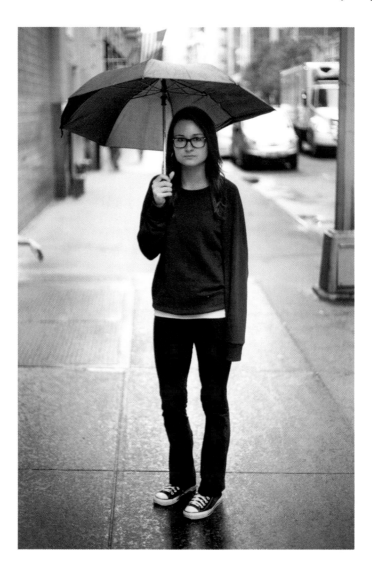

DRINKING/RECREATION

TOP THINGS MILLENNIALS DO AT BARS

TRY TO
CATCH THE
BARTENDER'S
EYE

TALK
ABOUT WHAT
OTHER BAR
TO GO TO
INSTEAD

DRINK
IN SILENCE

DRINKING AND SOCIAL POLITICS

NUMBER
OF DRINKS
CONSUMED

"BUT,
LIKE,
WHAT DOES
CONGRESS
ACTUALLY *DO*?"

LIKELINESS YOU WILL JEOPARDIZE
THE INTRICATE WEB OF LIES
THAT YOUR SOCIAL STANDING
DEPENDS ON

BAR GRAPH

HOW TO TELL WHEN A MALE MILLENNIAL IS TOO INTOXICATED

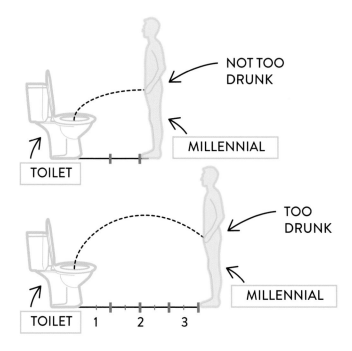

NOT TOO DRUNK

MILLENNIAL

TOILET

TOO DRUNK

MILLENNIAL

TOILET 1 2 3

STATS

Most Popular Drugs Among Millennials
1. Weed
2. Cocaine
3. Caffeine
4. Molly
5. Mushrooms
6. Deciding to cancel plans

Average Amount of Urine Deposited into Underwear While Waiting in Line for Bar Bathroom Each Year

5 grams

Decibel Level Where Most Millennials Will Laugh at Something Instead of Asking Another Person to Repeat Themselves at a Crowded Bar

87

"I love cargo shorts. The extra pockets are perfect for storing all of the underwear women randomly throw at me when I'm walking down the street."

Matthew, sexy

216 ALEC MacDONALD AND CONNOR TOOLE

"Imagine walking through the streets of London on a peaceful warm September week-end in 1940 with a hunk of fried fish wrapped in month-old newspaper in one hand and a bottle of malt vinegar in the other—when, all of a sudden, the sirens start to blare. Their howling shriek fractures the tranquility of the beautiful day in an instant. In a blur of panic, you try to remember the location of the nearest bomb shelter—your wife *told* you to memorize them, but you thought she was overreacting, as women always do (god, she hates when you talk like that, and you know you should stop, but it's a hard habit to shake—after all, your whiskey-guzzling father was constantly lecturing you on the frivol-ity of women). Suddenly: a huge sound, like a thunderclap, and the windows of a nearby window send their glass raining into the street. You run toward the Underground in the shower of broken glass. You don't dare to look up to try to see one of the German bomb-ers. There are more explosions in the distance, the roaring steadily growing louder. As you run, you think of your wife—wondering if you'll ever stare into her hazel eyes again, ever hear her easy laughter. The sky is filled now with the clanging sounds of destruction. There is nowhere to go. God, what is this all for? When will the madness finally stop? When will man finally understand that we don't have to do this to each other? Anyway, that's kind of how I feel when I'm on the subway and someone yells 'SHOWTIME!'"

Ethan, unpublished novelist

"I met my girlfriend after I got way too drunk on a Saturday afternoon and started to Tinder indiscriminately. She told me she had an acronym fetish, so we met up at the TGI Fridays in Penn Station and I got an OTPHJ in the bathroom of an LIRR train to JFK. It was just like a Woody Allen movie."

Jake, blogger

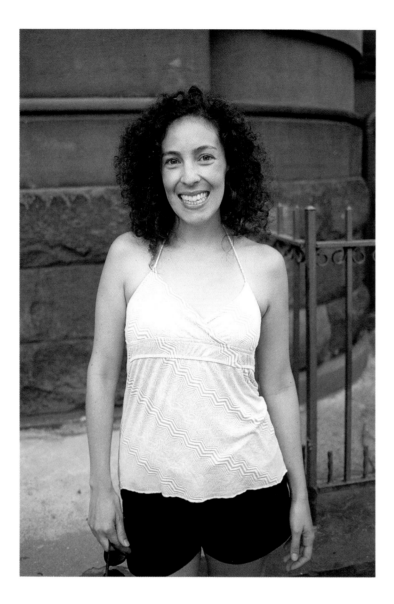

"I once saw two rats fighting on the subway tracks—I mean really going at it—until all of a sudden one of them squealed horribly and stopped moving. I looked closer and saw a tiny neon pink handle sticking out of its back . . . it had been impaled by one of those tiny pink plastic swords they use to garnish drinks at tiki bars. The victor scuttled away, but was hit by an oncoming train half a second later. War is hell."

Victoria, bodega cat rehabilitator

"If I had a time machine, I would use it to travel to September 10, 2001, and stop myself from buying all those Beanie Babies."

Mike, caterer

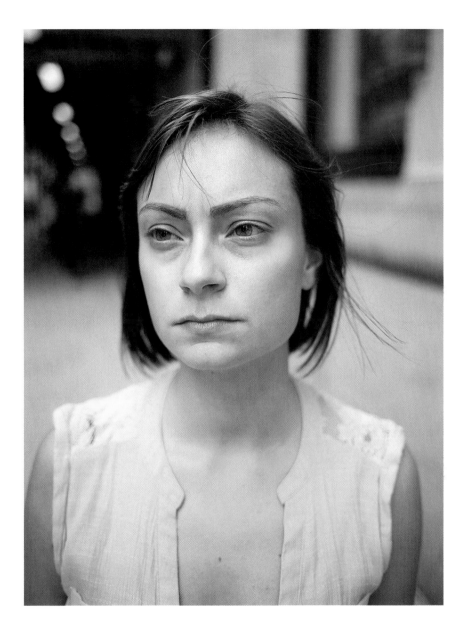

"I got my first dick pic this week. I'm not positive, but I don't think my mom ever had to deal with a guy confidently handing her a Polaroid of his sex organ on a first date. What guys these days need to understand is that a picture of a penis is like a picture of chocolate pudding: When you're hungry it's cool, but when you aren't it just looks like diarrhea."

Regina, publishing assistant

"I work for a start-up that's trying to design a candle that smells like a candle store. We're hoping Google will eventually figure out a reason they need to buy us."

Terri, Bing user

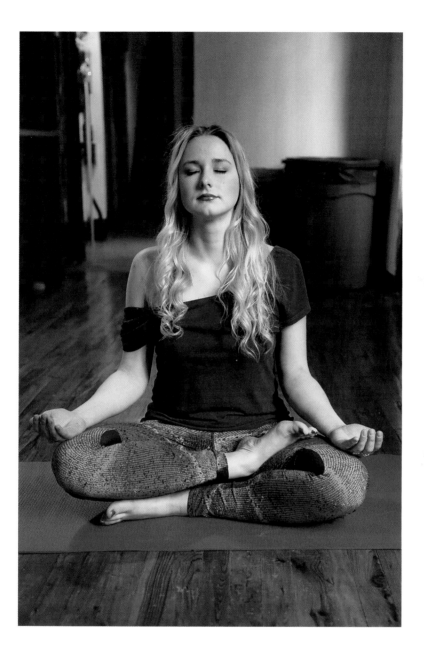

"I love meditating. It just really helps me get back in touch with how much better I am than you."

Leigh, entertainment reporter

"The future terrifies me. There are so many serious issues being ignored by today's society, and I'm honestly afraid of what I'm going to tell my kids. Are we going to wait until Times Square becomes the world's largest water park before addressing climate change? Does North Korea have to invade China before we stop ignoring their blatant abuse of human rights? And Guy Fieri? How am I supposed to explain Guy Fieri? 'Well, there once was a backup singer from Smash Mouth who loved cooking almost as much as he loved wearing shirts with flames on them. He gave us Guy's Happenin' Habanero Hot Dog Egg Rolls, and we gave him all our money.'"

Jeremy, architect

"I watch a ton of porn. I'm not embarrassed to say that. After all, the best thing about porn is it showed guys like me how sex is supposed to be done. Like, if I'd never seen any porn before, I totally would have never known that girls really love it when you sex on them like an enraged construction worker frantically drilling through concrete to reach a broken water main. Or that all women are attracted to facial hair that says, 'Yes, I've tried meth and have a green belt in karate.'"

Colin, barback

"The other day someone told me I reminded them of Jason Schwartzman. I still haven't figured out if they meant it as an insult or a compliment."

William, taxidermist

"I love the New York dating scene because all of the women here are so mature and independent. You can go into a bar, tap a girl on the shoulder and say 'Hey, you wanna go pork each other in the unisex bathroom?' and she'll just be like, 'No. Thank you.' And, you know, I respect that."

Don, sales

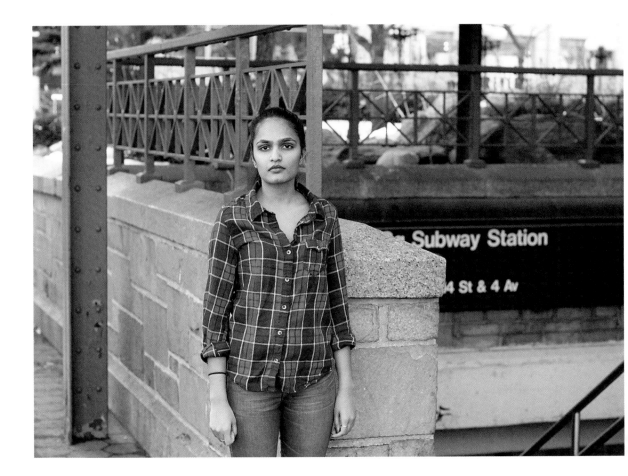

"I once spent three straight days alone in my apartment. I turned my phone off. I didn't go on the internet. And when the delivery guy came to deliver food, I didn't speak or look at him. After that, I boarded up my windows and broke up with my girlfriend. My mother was convinced I was on the verge of a mental breakdown. When she came to check on me I put a cabinet in front of the door and pretended I wasn't home. Thinking I might have died, the cops broke through the barricade. They found me with my eyes closed and my hands over my ears, screaming. I refused to leave the apartment, so they brought in a therapist to see if I had to be committed to an asylum. He asked me if I was hearing voices. I told him no, I was just *really* scared of spoilers."

Loretta, Amazon Prime member

"I'm the person who wrote the Wikipedia article about Suri Cruise's eyebrows."

Beth, talent scout

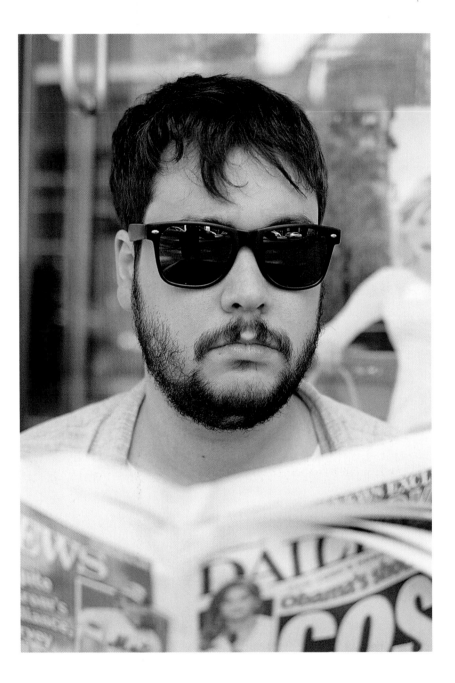

"I'm the person who's been leaving all those
homophobic comments on YouTube videos of cats."

Brian, men's rights activist

"I'm a feminist, okay? And I don't care who knows it. I believe that women are JUST as capable as men, and deserve the right to equal pay. Guys who wouldn't vote for someone based on their gender offend me to my core. It's ridiculous, in this day and age, to have a problem with a woman in a position of power. Personally, I would be overjoyed with a female president if she's not fat."

Nick, feminist

"I'm the person who came up with the phrase 'Netflix and chill.'"

And how does that make you feel?

"I understand how Oppenheimer felt."

Vanessa, digital video coordinator

FOOTNOTES

1. Pg. 88: "私は日本が大好き" (Translation: "I love Japanese things.")

2. Alec wears a size 8.5 shoe.

3. Connor wears a size 16 shoe.

4. Alec's feet are heavily arched, which has helped him in running away quickly from drunk, angry men outside of bars. His father, whose arches he inherited, was an Olympic hurdler.

5. Connor has to shop for shoes online, because stores do not carry the size he needs.

6. Alec once sprained his big toe while trying to impersonate a ballerina while on a field trip to the beach.

7. Connor's shoes cost more because they require nearly twice the materials to make.

8. One of Alec's shoes can fit snugly in one of Connor's shoes.

9. Alec does not wash his feet because he believes that when he showers "the soap flows down there anyway."

10. Quentin Tarantino clearly has a foot fetish.

11. Uma Thurman wears a size 11 shoe.

12. Quentin Tarantino makes great movies but is sort of a creep.

13. Alec and Connor believe Quentin Tarantino would rather live in a world without hospitals than a world without feet.

14. That is only their opinion though.

ACKNOWLEDGMENTS

First off, we want to thank *Elite Daily* for supporting this project, Greg Dybec (who was our guardian millennial), and all our coworkers who made up a large portion of the subjects on the Facebook page in the early days and were nice enough to let us make up terrible things about them.

Thanks also to Kimberly Hoyos and Vanessa Rees, who took many of the photographs featured in this book. Go hire them.

We'd like to thank our tireless agent, Kathleen Nishimoto, and our magnificent editor, Natasha Simons, along with everyone else at Gallery Books who made this weird book possible.

Thanks to *Millennials of New York* caption-contest winner Julia Monahan, who wrote the hilarious caption on page 113.

Alec wants to thank Anne Louise and his friends, for telling him he was funny. And he'd like to thank his family, for telling him he wasn't.

Connor would like to thank his parents for putting up with him for so long, Hannah Kapsak for dealing with so many terrible jokes over the years, and the patrons of the Whole Foods in Gowanus for all the inspiration.

We would specifically like to not acknowledge Jeff. He knows why.

Any questions? Call Alec at 646-776-4451.

ABOUT THE AUTHORS

© Alec MacDonald

CONNOR TOOLE is a writer, comedian, and cliché living in Brooklyn. He attended Boston College, where he performed sketch and improv comedy before graduating in 2013 with a double major in subjects he never particularly cared for. He wrote for *Barstool Sports* before accepting a position at *Elite Daily* and becoming yet another millennial in New York. His hobbies include using his interest in craft beer and inventive cocktails to justify drinking as much as he does.

© Alec MacDonald

ALEC MacDONALD is a writer and comedian born and raised in New York City. He went to Vassar College for his BA and then Sarah Lawrence, where he received an extremely lucrative MFA in fiction writing (also known as "make-believe") in 2014. He currently works as a humor writer for *Elite Daily*, where he learned about all the millennials he makes fun of in this book. He loves you all very much.